IMAGES
of America

FORT WORTH'S
ARLINGTON
HEIGHTS

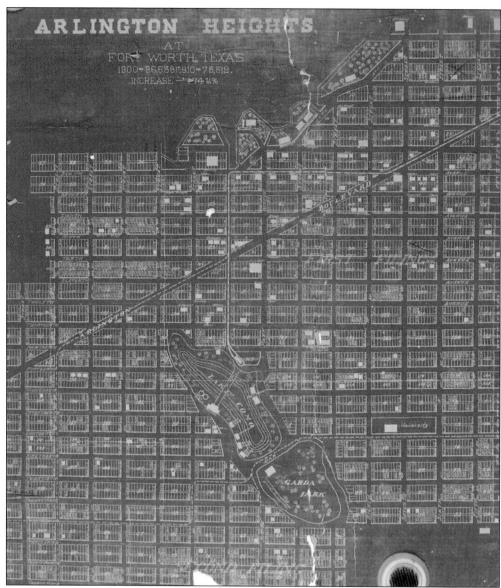

From the second period of development, a c. 1910 plat map preserved by Robert Lee McCart and his heirs shows the beginnings of a community—homes, a streetcar line, roads, a lake, parks, schools, a country club, a sanitarium—and the persistence of wide-open spaces on the high prairie. (Courtesy of Alice Roberta McCart Walters and Roberta E. McAllister; photograph by Bob Lukeman.)

ON THE COVER: Wesley Capers Stripling, a downtown department store proprietor, hosted a picnic for his employees June 2, 1910, at Lake Como. As reported in the *Fort Worth Star-Telegram*, "They were taken to the park in special cars that left the main gate of the city at 6:30 o'clock, and when they reached the lake, a fine supper was served. Rides on various amusement devices, dancing, and rowing took up the time of Mr. Stripling's guests until a late hour." (Courtesy of the *Fort Worth Star-Telegram* Collection, Special Collections, the University of Texas at Arlington Library, Arlington.)

IMAGES
of America

FORT WORTH'S ARLINGTON HEIGHTS

Juliet George

ARCADIA
PUBLISHING

Published by Arcadia Publishing
Charleston, South Carolina

Printed in the United States of America

Library of Congress Control Number: 2009941018

For all general information contact Arcadia Publishing at:
Telephone 843-853-2070
Fax 843-853-0044
E-mail sales@arcadiapublishing.com
For customer service and orders:
Toll-Free 1-888-313-2665

Visit us on the Internet at www.arcadiapublishing.com

*For Christina Patoski, who wrote, "I'm in love with our neighborhood,"
and for all the neighbors—past, present, and future.*

CONTENTS

ACKNOWLEDGMENTS

It is a real honor to work with people who share history, memory, and treasured icons. Their generosity of time and spirit signifies community. Space does not permit explanations or elaborations. I hope no names have been inadvertently omitted, as all were important and greatly appreciated.

Hearfelt thanks to Luther Adkins, Ron Abram, Lauren Algee, John W. Arnn, Kathi Baker, Scott Barker, Barron Photografix, Ltd., Owen Baumgardner, Ryan Bean, Linda and Mike Beaupré, Phil Besselievre, James T. Blanton, Sue Wells Brasher, Dena Mahaffey Brown, Roy Lee and Ellen Brown, Kathy Broyles, Kathleen Bruton, Sumter Bruton, Nancy Sommerville Buckman, James Buehrig, Wayne E. "Chubby" Buehrig, Frank and Sue Burkett, Libby Buuck, Paul Camfield, Camp Bowie Color Lab, Pam and William Campbell, Charles Cannon, Caroline Willett Carson, Pete Charlton, Jim Ed Clark, Suzy Coleman, Anna Mae Buehrig Connor, David Cooper, Carol Grimland Couch, Judith McKinley Crowder, Bro and Dede D'Arcy, Hamlet D'Arcy, Joyce Grimland David, J. Paul Davidson, Jim Dawson, C. Jane Dees, Willie Dees, Kristi de Merlier, Dorothy Paddock Dixson, Chrissy Dombrowski, Gregory Dow, Ben Eastman Jr., Gordon Eastman, Geraldine Emmons, Beth Phillips Engelhardt, Environmental Systems Research Institute Mapping Center, Melinda Esco, Brice Evans, Joy K. Evetts, James Finn, Rev. Michael Fielding, Robert W. Flournoy, Marianna Rucker Foringer, Jonathan Frembling, Barbara Friedman, Walker C. Friedman, Kathleen Fulton, Mary Galindo, Caroline DeWolfe Gant, Jean and Bob Gates, Aryn Glazier, Lory Friedman Goggins, Joan Gosnell, Nancy Dangler Grasshoff, John Graves, the Griffey family, Josephine Grimes, Ric and Becky Grimland, James Gudat, Floyd S. Gunn, Ben Guttery, Steven W. Hagstrom, Gayle W. Hanson, Lisa Helbing, Ann Hodges, Dalton Hoffman, Carol Holze, Marvin Hudson, Lenna Hughes, Ben Huseman, Hilda Cohen Jackman, Monika Olszer Jasinska, Tom Kellam, Janet Kettner, Bud Kennedy, Susan Allen Kline, Susan Applegate Krouse, Donna Kruse, Nancy Lamb, Sheila K. Leach, Alan Lefever, Lauren Leonard, Marty Leonard, David and Marilyn Lewis, Eloise Lievrouw, Bob Lukeman, Roberta E. McAllister, Joe McCary, Brenda McClurkin, Michael McDermott, Quentin McGown, DeAnn McKinley, Francis Willburn Mahaffey, Irene McKinley Martinez, Bill and Patricia Collins Massad, Aglaia Dixie Mauzy, Cholmeley J. Messer, Joel Minor, Dianna Mitchell, Maggie Mooney, Rev. Larry Mouton, George Neely, J'Nell Pate, Christina Patoski, Joe Nick Patoski, David Pearson, Susan Petty, Shawn Phillips, Tommy and Margie Wise Phillips, Gina Prill, Marsha Prior, Susan Murrin Pritchett, Donald and Rosemary Rainbird, Claudia M. Ramirez, Stylle and Nancy Read, Alice Rhoades, Margie Bertelsen Rhoades, August Riccono, Carol Roark, John Roberts, Arthur Robertson, John Robertson, Bonnie Rowan, Bob Ray Sanders, Rev. R.L. Sanders, Pamela Sanguinet, Lynny Weil Sankary, Joanne Sarsgard, Richard Selcer, Ellen Sieber, Marcus Smith Jr., Royse Smith Jr., Edgar Snelson, Lou Snow, Cathy Spitzenberger, Ann Stahl, Janet Stewart, James and Mahala Yates Stripling, Karl Thibodeaux, Bill Thompson, Susan Hoera Toppin, Jerre Tracy, William J. Trotter, Estrus Tucker, Susan Urshel and Paul Schmidt, Bubba and Julie Litsey Voigt, Harriett Wahler, Sarah Walker, Sylvia Belle George Walls, Alice Roberta McCart Walters, Leon Walters, Shnease Webb, Wyatt and Sheila Webb, Arthur Weinman, Linard O'Neal Wells Jr., Jack White, Brianna Wilcox, David Williams, Joyce E. Williams, and Elizabeth H. Wood. I am especially grateful to Arcadia's wonderful Southwest publisher, Kristie Kelly, and production coordinator David Mandel.

INTRODUCTION

Rolling over the red bricks that pave Arlington Heights' Camp Bowie Boulevard, motorists who call the neighborhood home can tell by the low-pitched rumbling sound and vibrations that they are traveling the main road through their *patria chica*, their little homeland. For many, it is more than a thoroughfare.

A small album of vintage neighborhood photographs and minimal narrative inevitably makes brief reference to architectural, social, religious, and other specialized branches of history. Images lead to related images. Stories lead, Scheherazade-like, to more and much longer stories. One volume will not hold them all.

As historians of border areas know well, that which lies just over a boundary is also part of the picture. Developers envisioned Arlington Heights reaching further south, whereas recent neighborhood association parameters mark how it has receded. Rivercrest, Monticello, Factory Place, Brooklyn Heights, Alamo Heights, *El TP* (a Spanish name for the Texas and Pacific railyard vicinity), and other areas relate and overlap. *Fort Worth Star-Telegram* columnist Bud Kennedy distinguished between adjacent neighborhoods in an essay reprinted in the Texas Christian University Press anthology *Literary Fort Worth*: "I remember my mother telling a delivery driver our address was in Arlington Heights, then adding: 'Well—it's kind of the bottom of Arlington Heights.' " After an earlier column inspired a former neighbor to call and reminisce with him, Kennedy noted that late-20th-century residents refer to his area as Alamo Heights or T&P, but emphasized, "We still call it Brooklyn Heights."

Latinos have been present, though relatively few in number. For decades, the Pineda family lived on Carleton Avenue, a few blocks from their Original Mexican Eats Café, and Frank Delgado was resident gardener at the Dorothy Lane Apartments. A Greek presence has also contributed to commercial and residential history.

The suburb's development paralleled that of the Jim Crow era, with its codified and unspoken restrictions that kept African American and other populations out. Arlington Heights and Lake Como are interwoven and symbiotic, though long segregated. However, domestic employees once lived in back houses or garage apartments on employers' properties and some accompanied them on family vacations. After World War I, "almost all of the women [of Lake Como] worked in Arlington Heights, which they called 'Little California,' " noted sociologist Joyce E. Williams in her study *Black Community Control: A Study of Transition in a Texas Ghetto*. Reflecting on that metaphor in 2009, she wrote, "California was largely represented by fantasy and some vicarious experiences via relatives and friends . . . perceived in terms of 'glitz and glamour' . . . the land of promise, but in a somewhat unreal and unknown way . . . the second implied meaning was that California had a reputation from earlier days for its boom and bust 'gold-rush' type of experience for those who followed their dream west. . . . Arlington Heights also had a kind of boom and bust history. And many in Como knew African Americans who had moved to California. Some had 'made it' and some had not. And so they associated California with following a dream that might turn out to be unfulfilled."

Keepers of Arlington Heights' past include Angie Stahl (now grown), who researched and wrote a handmade book about the history of North Hi-Mount Elementary School while she was a student there. Western swing musician Roy Lee Brown collaborates with music historians and keeps alive his family's rich tradition. In addition to the indelible images, they preserve what—in 21st-century lingo—are called back-stories.

Formal commemoration includes seven Texas Historical Commission markers: the Arlington Heights Masonic Lodge, the second Baldridge house, Bryce house (Fairview), Camp Bowie, Camp Bowie Boulevard, Sanguinet house, and Zion Missionary Baptist Church in Lake Como. In 1988, the Historic Preservation Council of Fort Worth and Tarrant County listed more than 90 significant Arlington Heights properties (several of which have since been demolished), including potential National Register of Historic Places candidates. Its successor, Historic Fort Worth, Inc., continues to advance the preservation cause. Businesses affiliated with Historic Camp Bowie, Inc., have invested in a boulevard beautification program and livened things up with an annual outdoor jazz festival. To the southwest, the Fort Worth Prairie Park Initiative of the Great Plains Restoration Council represents an effort to preserve a portion of still-undeveloped land in its natural state.

Frank Burkett began a successful campaign in the late 1970s to keep traditional materials (originally Thurber bricks from Erath County) on Camp Bowie Boulevard. Although the road began as a rough and muddy route and went through an early paving phase with creosoted wood blocks, the bricks have provided continuity and color since the 1920s.

The late Julien C. Hyer, federal judge and judge advocate at the Nuremberg trials, was a longtime Arlington Heights resident and the father of actress Martha Hyer. He began the 12th chapter of his book, *The Land of Beginning Again*, by quoting from Thomas Carlyle: "History is the essence of innumerable biographies." Similarly, Christina Patoski, past president of our neighborhood association, wrote in 2006 of "the incredibly diverse and interesting people who have chosen to make their homes here." They—as much as the appearance of the place—make Arlington Heights a compelling subject. On this 220-stop cook's tour, one may see some of them in context.

One

PRIMORDIAL AND
PREHISTORIC

SUBTLE LEGACIES

Where we now live, snake-like beasts with sharp teeth, long, cumbrous tails and short, heavy legs,
waddled in the soft muds of the shore and over the semi-arid lands. Upon the bottoms of the water
bodies, as well as during the following periods, the Triassic and Jurassic, great deposits of gypsum and
salt and dolomite were made. We are plastering and whitening the walls of our homes with the first,
sometimes building them of the last and seasoning our food and feeding our cattle with the other.

—Edward Allison Hill in *Geological Notes on Oil Structures*
(San Francisco: Hall-Gutstadt Company, Publishers, 1922)

Geologist Edward Hill knew how to bridge the gap between ancient and modern residents. While profiting from the oil boom, he also sought to explain his science in a 1921 *Fort Worth Star-Telegram* article and, again, in a book.

An earlier report on what lay beneath the Fort Worth Prairie, authored by Robert T. Hill for the United States Geological Survey in 1900, and another on Camp Bowie by Ellis Shuler in 1917, carried the same fossil illustrations. Above ground, before settlement, short grasses grew on ridge tops, Little Bluestem on slopes, and Indiangrass and Big Bluestem in valleys, according to Tony Burgess, environmental scientist at Texas Christian University.

Humans camped beside the Trinity River's Clear Fork 3,000 years ago, as archaeologists excavating near the Bryant-Irvin Road crossing found in 2005. The team found hearths, bones, and artifacts.

Documenting native people's footprints is incomplete and complicated by folklore. "The Comanche, despite figuring prominently in the imaginations of Texans, were relative newcomers to Texas [1700s]," noted archaeologist John W. Arnn of the Texas Department of Transportation's environmental affairs division. "There were, no doubt, dozens, if not hundreds, of culture groups that preceded them in the approximately 15,000 to 20,000 years of prehistory."

Remnants of the more recent past wait underfoot. Ranchers moved to lands west of Fort Worth after the city's founding as a military outpost in 1849, and some homeowners find ruins of older foundations below their own pier-and-beam underpinnings. Gardeners occasionally uncover army souvenirs from 1917–1919 as they turn over the prairie earth.

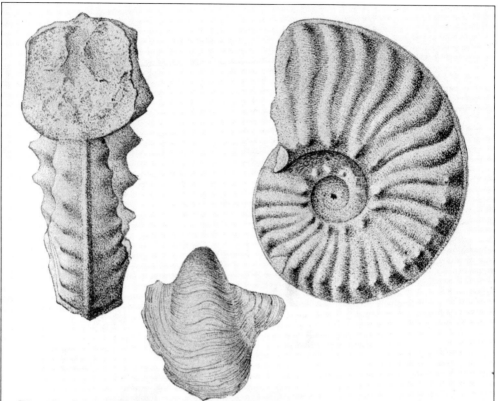

Plate I. Left side: Ammonites Conensis Roemer. From the Fort Worth
Limestone.
Right side: Same; a side view.
Below: Gryphaea Washitaensis Hill. From the Dennison beds.

Ammonites Conensis Roemer illustrated geologist Robert T. Hill's 1899–1900 U.S. Geological Survey report on the Fort Worth Limestone Formation. Considered "index fossils," ammonites indicate ages of other nearby specimens. In 1917, colleague Ellis Shuler selected this and other fossil images from the Hill study to accompany his essay on Arlington Heights' fitness as a training ground for digging and fighting in France. (Courtesy of the Dolph Briscoe Center for American History, the University of Texas at Austin.)

Edward Allison Hill, consulting geologist and oil operator, authored monographs on the science behind oil. He worked in several states, owned property in Fort Worth, and reprised his *Fort Worth Star-Telegram* essay in his 1922 book. Hill's California publisher, Richard E. Gutstadt, would later become better known for his service as executive director of the B'nai B'rith Anti-Defamation League. (Author's collection.)

10

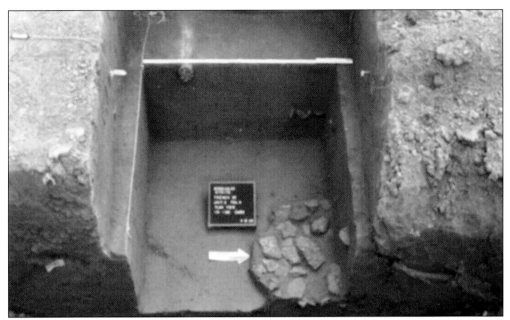

At an excavation site where Bryant-Irvin Road crosses over the Trinity River's Clear Fork, archaeologists found that this oval, basin-shaped configuration "was clearly a deep pit hearth or small oven feature, with a layer of rocks capping the fill matrix." It measured 40-by-58 centimeters and had a depth of 160 centimeters; the team recovered 107 burnt rocks. (Courtesy of the Texas Department of Transportation, Environmental Affairs Division.)

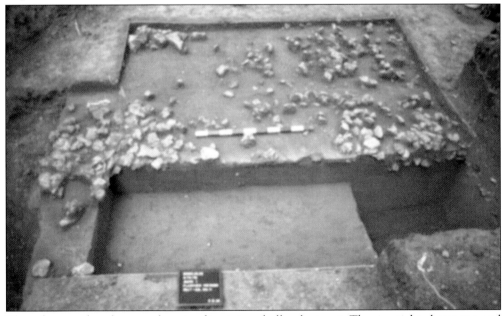

Three features show burnt rocks extending into a shallow basin pit. The size, tight placement, and relative flatness of the rocks at the lower right, together with other factors, led the archaeologists to state that "it is possible that this feature might have served as a large griddle or some other kind of flat heating hearth surface." (Courtesy of the Texas Department of Transportation, Environmental Affairs Division.)

Tony L. Burgess, environmental scientist at Texas Christian University, described a present-day vegetation scene characteristic of predevelopment Arlington Heights as following: "A dense stand of Little Bluestem grass (*Schizachyrium scoparium*) on the Fort Worth Prairie. It is late autumn, and most of the fuzzy seeds have dropped, and the stems have assumed the reddish-copper hue that will tint grassy bands along the prairie slopes during winter." (Photograph by and courtesy of David Williams, TCU.)

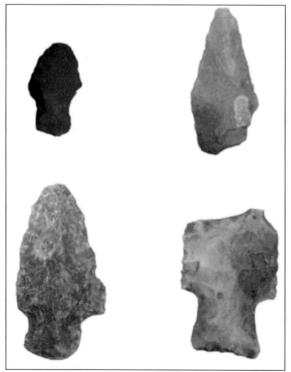

Projectile points uncovered at the site included (clockwise from top left) a possible Dallas point, unknown dart point, Trinity point, and Yarborough point, which were all classified as Middle and Late Archaic dart point forms. Bone fragments from bison, white-tailed deer, rabbits, hares, fish, dogs, and hispid cotton rats, and shells of terrestrial and aquatic turtles and mussels were excavated. (Courtesy of the Texas Department of Transportation, Environmental Affairs Division.)

Two

ASCENDING TO THE HEIGHTS, FALLING WITH THE SILVER

1889–1893

For he himself has said it, and it's greatly to his credit, that he is an Englishman! . . . But in spite of all temptations to belong to other nations, He remains an Englishman! He remains an Englishman!

—William Schwenck Gilbert

Was it a habitat rich with native grasses and strewn with wildflowers, or a 2,000-acre "waste of land" (as one *New York Times* writer disparaged)? Humphrey Barker Chamberlin of Denver foresaw an opulent suburb to the west of Fort Worth, and its creation was launched in 1889.

For the encore to his development of Denver's Capitol Hill, he attracted local and faraway investors. He called Fort Worth "the brilliant in the coronet of the Great Southwest," while projecting sister suburbs for other cities in Colorado, Montana, Washington, and Texas. A trolley line would connect residents to Fort Worth. Two lakes, a waterworks, and an electric plant would hydrate and power it. What better way to inspire prospects than with a model mansion and an old-world inn?

Chamberlin Arlington Heights gloried briefly. With the Silver Panic of 1893, the overextended empire collapsed. Losses made headlines in several states; he addressed creditors publicly and left the country.

His life began in England, but Chamberlin had embraced the United States. He started modestly, advanced in business, and became a classic risk-taker, amateur astronomer, and extravagant philanthropist. He returned to England after failure and worked for others. On a cycling trip in 1897, the peripatetic 50-year-old fell from his bicycle and died on the road between Surbiton and Egham in Staines, Surrey. First reports indicated he was killed, but later accounts attributed his death to syncope and a weak heart.

The Royal Astronomical Society's obituary for Chamberlin, in *The Observatory*, closed with gentle words for a man credited with a "singularly kind and sympathetic character." "We may mourn his premature death, but there is something peculiarly fitting in the manner of it. After the strain and stress of an unusually full life he passed painlessly away quite early on a springtime morning in the quiet of an English country lane."

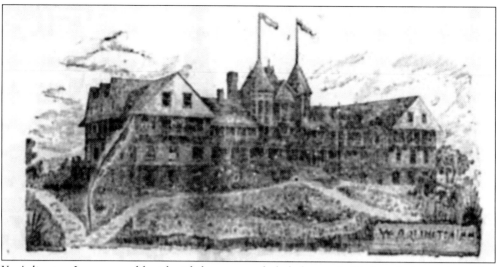

Ye Arlington Inn, a grand hotel with banners unfurled above a brick foundation and wooden superstructure, overlooked the Trinity's West Fork. A *New York Times* commentator, surveying new western hotels "into which much money has been sunk," called it "one of the most daring experiments ever made in hotel building." It made its final appearance in the *Fort Worth Daily Gazette* on November 12, 1894. (Courtesy of Pete Charlton.)

NATURE
GAVE TEXAS ARLINGTON HEIGHTS.

The enterprise, ability and judgment of man has taken advantage of nature's handiwork and the result is a model place of residence which possesses

ALL OF THE ADVANTAGES
AND NONE OF THE DRAWBACKS OF A CITY.

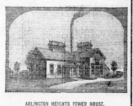

ARLINGTON HEIGHTS POWER HOUSE.

Rapid transit, macadamized boulevards, avenues and streets, a complete system of water works and an incandescent electric light system for house and street lighting, combined with the abundant gifts of nature, make

ARLINGTON HEIGHTS
the most desirable place of residence in Texas.

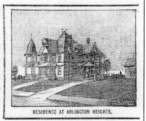

RESIDENCE AT ARLINGTON HEIGHTS.

To those desiring to build homes in this healthful locality liberal and satisfactory terms will be offered. INVESTORS are assured that property values are almost certain to double in value within the next two or three years, and are invited to critically investigate this investment.

For maps, terms and other information address or call on

THE CHAMBERLIN INVESTMENT CO., FOURTH AND RUSK STREETS.

With engravings of a powerhouse and a mansion, the Chamberlin venture's front-page advertisement in the *Fort Worth Daily Gazette* appealed to prospective residents and investors on September 25, 1890. Another version promised a college. (Courtesy of Pete Charlton.)

An abridged biography of Humphrey Barker Chamberlin rolls out as rapid-fire Gilbert and Sullivan verse. He was born in 1847 in Market Rasen, Lincolnshire, and moved with his family to Manchester and New York. Before getting a gleam in his eye about Fort Worth, he had been a Civil War telegrapher, opened drugstores, married and started a family, edited a Bible-verse handbook, directed a Brooklyn YMCA, partnered in a boot and shoe company, invested in mines, developed real estate, presided over the national YMCA, and led the Denver Chamber of Commerce. (Courtesy of the Denver Public Library, Western History Collection.)

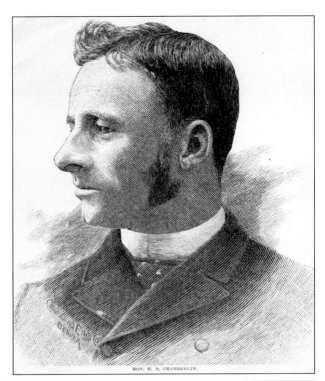

HON. H. B. CHAMBERLIN.

Chamberlin brothers H. B. and Alfred W. rented space in Fort Worth's new commercial gem, the Land Title Block, which was doubly linked to Arlington Heights through resident architect M. R. Sanguinet. It remains an exemplar of Victorian Romanesque style, artistic masonry, and use of colors and materials. Currently, pub goers hold forth where the Chamberlins once conducted business. (Collection of John W. Hackney; courtesy of the Amon Carter Museum.)

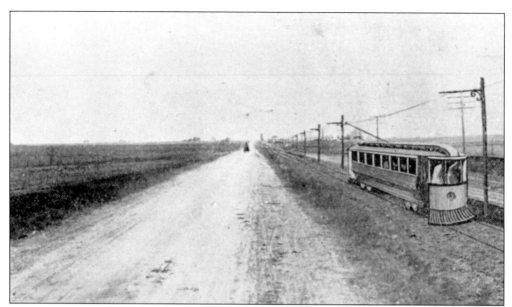

Arlington Heights Boulevard cut across the undeveloped, but not quite lone, prairie. Some night trolley passengers reported hearing wolf cries. They probably did; J. M. Butler, a government wolf trapper, caught a 60-pound red wolf on the nearby Cass Edwards ranch as late as October 30, 1928. (Courtesy of the Genealogy, History and Archives Unit, Fort Worth Public Library.)

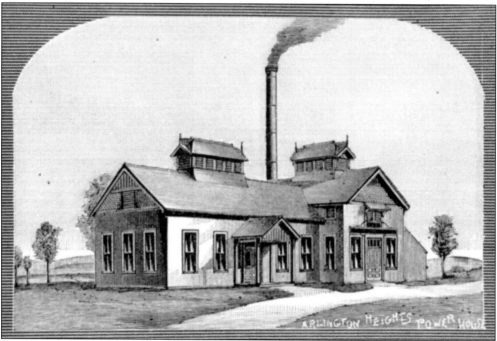

The powerhouse became a crime scene on January 7, 1891, as a fatal bullet raced from a Winchester rifle through a thin wall and into streetcar line manager David Dayton's bowels. A reporter from the *Dallas Morning News* termed it the "sequel to a rough and tumble fight." The slayer was James Bretherton, chief engineer. Dayton died January 9 at Henry W. and Sallie Tallant's residence. (Collection of John W. Hackney; courtesy of the Amon Carter Museum.)

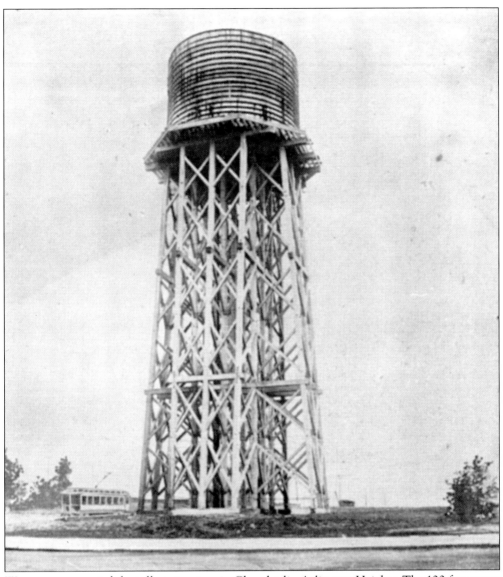

Water once occupied the tallest structure in Chamberlin Arlington Heights. The 100-foot tower cast a long shadow over the Lake Como hills, holding aloft more than enough for the few early residents. Water reservoirs wore dressier façades in Louisville, Chicago, and other U.S. cities, but in 1892 *The New England Magazine* published F. N. Clarke's essay on Fort Worth for its "New South" series, and he praised the Arlington Heights system. "Artesian wells have been sunk and an abundance of pure water secured," Clarke noted. "A pumping house conveys the water to a large elevated reservoir, standing on the crest of the Heights." The original tank lasted 16 years; the photograph could be of the first or second container topping the supports. This and other scenes from the suburb appeared in the c. 1905 booklet *Beautiful Arlington Heights*. "When the *Fort Worth Gazette*'s G. B. wrote of the waterworks, he mocked its "chuff, chuff, chuff, chuffing" and noted that horses and cattle drinking from the lake were the main clients. (Courtesy of the Genealogy, History and Archives Unit, Fort Worth Public Library.)

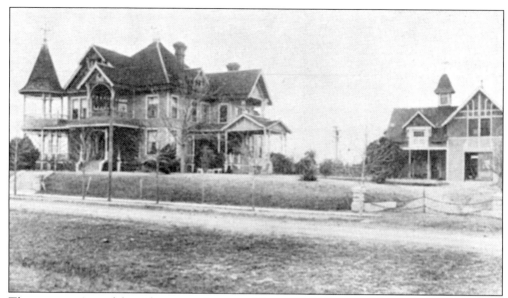

The company's model residence was home to Henry W. Tallant and his wife, Sallie. Tallant oversaw many aspects of development, from hotel construction to the transplanting of 3,000 trees from the Trinity valley. It is likely that he was the same H. W. Tallant who worked for the Denver mint in the 1880s. This and other early photographs from the suburb appeared in the c. 1905 promotional booklet *Beautiful Arlington Heights*. (Courtesy of the Genealogy, History and Archives Unit, Fort Worth Public Library.)

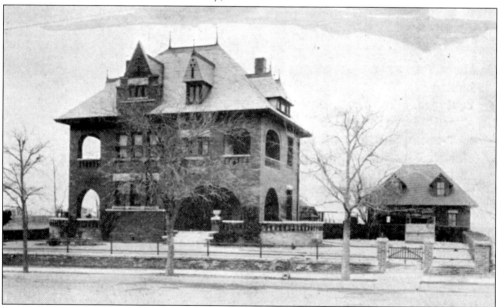

William Bryce came to Canada with his family from Woolyburn Farm, Lanarkshire, Scotland, and on his own from Ontario to Texas in 1883. His brother, Alexander, arrived to help build Fairview, the Châteauesque mansion on Bryce Avenue, but Alexander contracted typhus while there and died. In 1915, William organized a British-American society to raise funds for war orphans and starving mothers in Europe. The Acme Brick executive served as Fort Worth's mayor (1927–1933). (Courtesy of the Genealogy, History and Archives Unit, Fort Worth Public Library.)

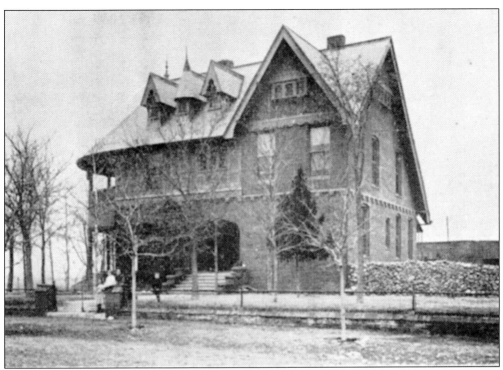

Arthur and Jessie Ligertwood Hickes Messer's home featured dormer windows of alternating design and a semicircular upper porch for catching cross-breezes. It stood on an eight-lot expanse purchased by Arthur and his brother in 1892. Following four families' residencies, a phase of science labs, and years of vacancy and vandalism, Marilyn and David Lewis purchased the house and converted it to a bed and breakfast. (Courtesy of the Genealogy, History and Archives Unit, Fort Worth Public Library.)

The widow Lillie Burgess Smith, daughter of cattleman J. W. Burgess, owned an Arlington Heights home, called the Hovenkamp house after she married again in 1915. The *Fort Worth Star-Telegram* wedding account included mention of M. W. Hovenkamp's Herefords having "taken blue ribbons at the leading stock shows." (Courtesy of the Genealogy, History and Archives Unit, Fort Worth Public Library.)

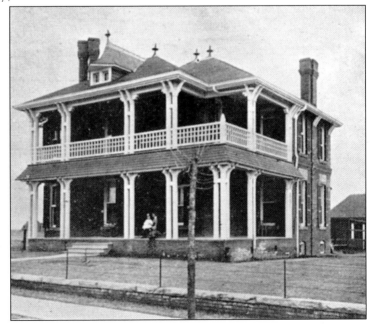

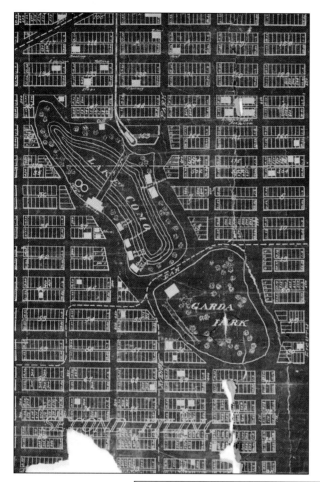

The Chamberlins evidently intended to create Lake Garda, which was a reference to another in a trio of northern Italian resort lakes. It is not known whether they planned to complete the tribute with a western Lake Maggiore. A city directory location listing and a lawsuit reported in a regional legal journal referred to Lake Garda, but the 1910 plat map showed only parkland near Lake Como. (Courtesy of Alice Roberta McCart Walters and Roberta E. McAllister.)

Lake Como's first pavilion was replaced by a simpler structure in the early 1900s. Lake Como was the namesake of a famous body of water in Italy. The *Fort Worth Star-Telegram* reprinted this vintage illustration in 1963. (Courtesy of Dalton Hoffman.)

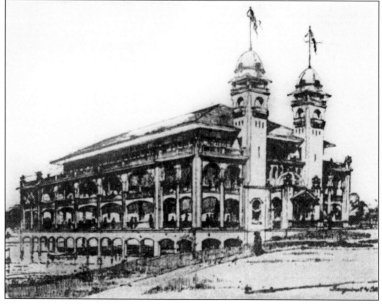

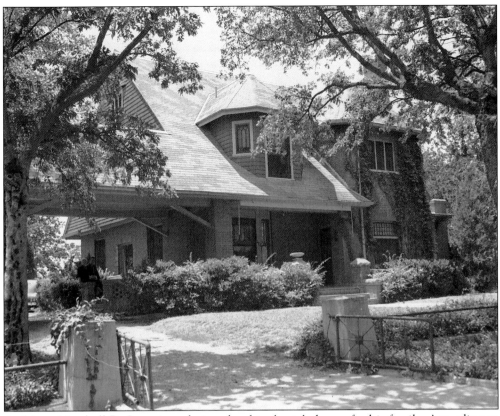

Architect Marshall R. Sanguinet designed a shingle style house for his family. According to Carol Roark in *Fort Worth's Legendary Landmarks*, the original 1890 house (fire-damaged and rebuilt with changes) was the first home in the Arlington Heights development. (Courtesy of the *Fort Worth Star-Telegram* Collection, Special Collections, the University of Texas at Arlington.)

Andrew Thomas Byers settled in the Heights. He was instrumental in the creation of Fort Worth's stockyards and known for the Byers/ Greenwall Opera House downtown. An incorporator of the Arlington Heights Automobile Company in 1903, he helped promote an alternative to streetcars. Ida Harrington Bidwell Byers, his wife, launched a 1910 campaign to introduce children to landscape beautification. (Courtesy of the *Fort Worth Star-Telegram* Collection, Special Collections, the University of Texas at Arlington.)

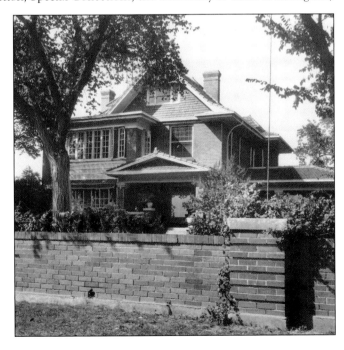

Arthur Albert Messer was one of several children of John Messer, a timber merchant who served as mayor of Reading, England, and Mary Wade Messer. Arthur was articled to a Birmingham architect from 1881 to 1884; next, he worked for other architects in England and New York, and reached Fort Worth in 1888. Among his early landmarks were the Texas Spring Palace and Galveston's courthouse. Arthur exchanged wedding vows with Jessie Ligertwood Hickes in Dallas at the Cathedral Church of St. Matthew, which he had designed, and the couple lived in one of the first great homes of Arlington Heights, which was also a Messer creation. Jessie came from a Scottish family associated with the Matador Ranch. Its first Scottish manager, William Fife Sommerville, had also bought land in Arlington Heights. (Courtesy of Derek Markham.)

Howard Messer joined his younger brother in the Fort Worth practice, which also included Marshall R. Sanguinet. Among his masterworks outside Arlington Heights was the Eddleman-McFarland home. He also designed Fort Worth's first All Saints' Episcopal Hospital. In April 1893, Howard explored the Trinity River to investigate its navigability. His fellow explorer described taking a 16-foot Canadian canoe through many turns in a waterway that "teamed [sic] with snakes and turtles." After returning to England in the early 20th century, he designed boats as well as homes. Another brother, Allan, once owned the famous yacht *Mariquita*. Howard traveled, lived for a time at a family home called Journey's End on West Mersea Island, and died at the age of 89 in Colchester. (Courtesy of Donald and Rosemary Rainbird and the West Mersea Island Museum.)

Marshall Robert Sanguinet, of French and French Canadian ancestry, left his birthplace of St. Louis in 1883 for Fort Worth, where he worked with the Messers to design early structures for Arlington Heights. In an essay for the Dallas Historical Society's journal *Legacies*, Barbara Brun-Ozuna noted "Sanguinet's progressivism and his appreciation for fine woodworking." He began designing, in 1905, an Arlington Heights Theater, proposed by a streetcar company, but evidently the project did not materialize. (Courtesy of the Texas/ Dallas Collection, Dallas Public Library.)

Carl Gordon Staats of New York, New York, first came to Texas to work for architect James Riely Gordon in San Antonio. In 1898, he left to serve as a draftsman in Sanguinet's office in Fort Worth; by 1902, they were partners. His first wife, Mollie Kline Staats, died in 1904. His second wife, Mary Jaycock Staats, led the Arlington Heights school board and advocated women's suffrage. Sanguinet and Staats created early skyscrapers and many Texas landmarks. Through six offices across Texas, the firm "transformed the scale and style of the state's rapidly growing cities," Christopher Long observed in his *Handbook of Texas Online* essay. (Courtesy of Gordon Eastman.)

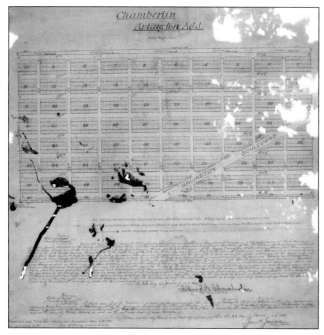

Alfred W. Chamberlin signed this 1890 plat map for a portion of Arlington Heights. The suburb would expand with other filings. (Courtesy of Alice Roberta McCart Walters and Roberta E. McAllister; photograph by Bob Lukeman.)

Managers of Arlington Heights' hotel invested in promotional World's Columbian Exposition picture books. The Chicago fair opened May 1, 1893; Chamberlin's disaster was announced July 10. On November 11, 1894, the inn caught fire and turned to charcoal, just prior to the Hotel Worth's grand opening downtown. Chamberlin secured a position with an American life insurance company in London. Adroit at connecting, he gained acceptance into the corresponding circle of Quatuor Coronati, the Masonic research lodge; worked with pharmaceutical magnate Henry Wellcome to found the American Society in London; and became a fellow of the Royal Astronomical Society. (Courtesy of Dalton Hoffman.)

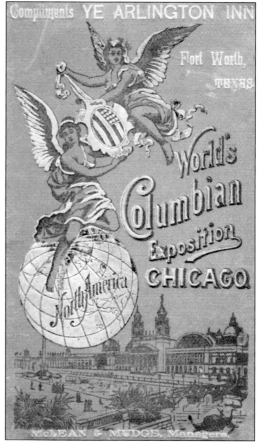

Three

BEAUTIFUL ARLINGTON HEIGHTS
CARRYING ON, SLOWLY

1893–1917

*Far above the smoke and grime of the noisy city, several hundred feet above
the City Hall, higher in altitude than any point in East Texas [sic], is beautiful
Arlington Heights, Fort Worth's most fashionable resident suburb.*

—Arlington Heights Realty Company

After the brothers from Denver had departed and the massive foreclosure concluded, most of Chamberlin Arlington Heights returned to attorney Robert Lee McCart, who held the vendor's lien. He, too, had projected a suburb. The demonstration mansion became the McCart home, and would remain in his family for four generations.

The World's Columbian Exposition of 1893 may have had some impact on the second wave of Arlington Heights promotion. The fair's neoclassical "White City" had complemented the City Beautiful movement (inspired by Georges-Eugène Haussmann's renovation of Paris in the 1860s) to lift morale and citizenship through design. In Fort Worth proper, landscape architect George Kessler was engaged to design a unified park and boulevard system, and the marketing language of Arlington Heights developers seemed to reference the movement. Edwin Gilpin Orr's *The Real Estate Broker's Cyclopedia* was a font of catch phrases and promotional themes across the country, including "The Suburb Beautiful" and "Up Above the Smoky Smoke."

Believers in restricted "place" additions opened Hi-Mount in 1906; buyers had to build $10,000 homes behind its stone entryways, and commerce was kept out. British consular agent Alfred Crebbin of Denver held 160 acres of Arlington Heights until 1910, when a consortium of purchasers introduced Hill Crest (later called Hillcrest) north and south of the Arlington Heights Road.

New institutions appeared in the still-rural setting. A small schoolhouse had served the first children, but a much larger public school opened in 1909. A girls' college and a sanitarium were established. Dairies operated, and one man's bulls tended to run loose in the neighborhood. Frank Sanguinet bought two Hi-Mount lots where he had recently hunted long-eared jackrabbits.

While development of genteel residential enclaves made slow progress, African Americans began to settle on the unsettled west side of Lake Como. They arrived as early as 1906 and started their homes, and a community, beyond the private park.

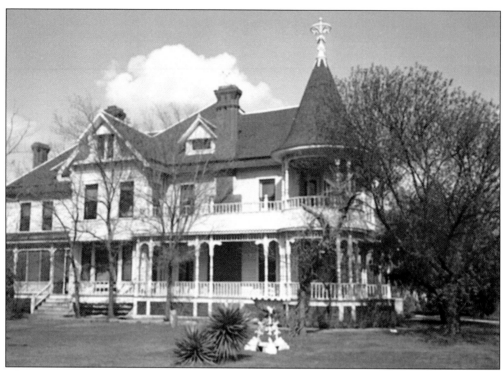

The house briefly identified with the Chamberlins and Tallants became the McCart home for four generations. From beginning to demolition, it was photographed, interpreted in paintings and engravings, and recognized as a landmark. An early engraving credits architects Haggart (S. B. or his son, Walter S.) and Sanguinet. (Courtesy of the *Fort Worth Star-Telegram* Collection, the University of Texas at Arlington.)

Robert Lee McCart of Flemingsburg, Kentucky, and Bloomington, Illinois, earned a law degree from the University of Michigan and opened a Fort Worth office with Frank Ball in 1877. He defended Luke Short, slayer of former sheriff Jim "Long Hair" Courtright, at his examing trial; served as city attorney and as a judge; and through his friendship with Adlai E. Stevenson, brought the Railway Mail Service to Fort Worth. His photograph appeared in the 1903 edition of *Men of Texas*, and he was recognized in *The New Encyclopedia of Texas.* (Courtesy of Alice Roberta McCart Walters and Roberta E. McAllister.)

Frances Electa Knepfly McCart was the daughter of John Knepfly, owner of the Knepfly Jewelry Company in downtown Dallas. Robert and Frances, called Fanny, traveled to San Francisco to select furniture for the home where they would host many social events. They celebrated their 50th anniversary in February 1932. (Courtesy of Alice Roberta McCart Walters and Roberta E. McAllister.)

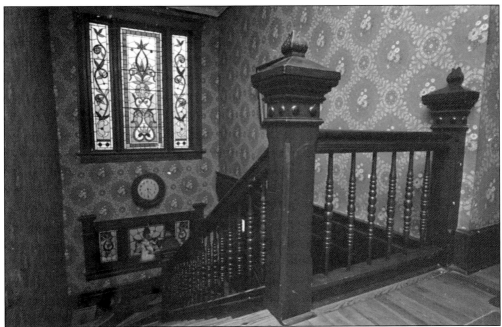

The landing on the McCart mansion's main stairway was photographed in 1941 for a full-page newspaper feature. (Courtesy of *Fort Worth Star-Telegram* Collection, Special Collections, the University of Texas at Arlington.)

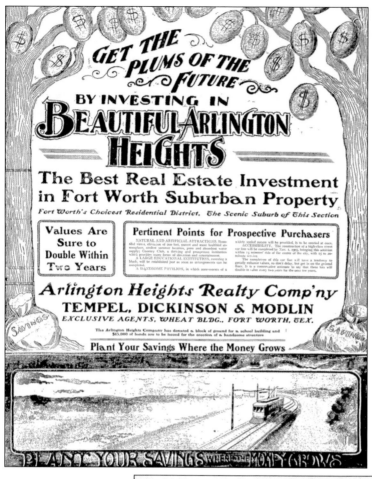

Dangling plums of lucre, Arlington Heights Realty Company launched an extensive campaign in the fall of 1905 to publicize its renewed suburban development. The unofficial renaming of "Beautiful Arlington Heights" set aside the name "Chamberlin" as successors appealed to skeptical prospects in large *Fort Worth Star-Telegram advertisements.* (From GenealogyBank.com and published by NewsBank Inc.)

Appealing to those who would build substantial homes, the new developers commissioned an attractive nine-room headquarters just across from the country club. Company officers conducted transactions on the ground floor, and "bachelor quarters" were held upstairs. (Courtesy of Dalton Hoffman.)

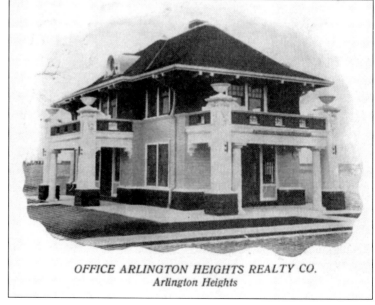

OFFICE ARLINGTON HEIGHTS REALTY CO.
Arlington Heights

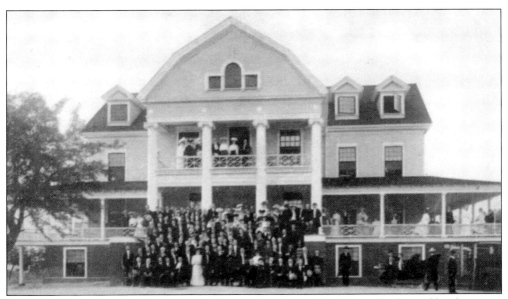

The Fort Worth Country Club, an exclusive retreat, opened in 1902 as the first golf and country club in the area. Marshall Sanguinet designed the clubhouse. As Quentin McGown noted in *Fort Worth in Vintage Postcards*, discussion of a club began after the 1894 fire that destroyed Ye Arlington Inn. Rivercrest Country Club took its place. (Courtesy of Lisa Helbing.)

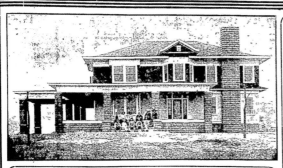

Carlos Alastaire Raoul Gotesmani, formerly with Central Accident of Pittsburgh, paid $400,000 in 1910 for West Side Realty Company holdings, promoting Hi-Mount and "Avalon, the suburb delightful," and pledging to import 100-130 glassblowers to Factory Place. He died in 1912 in Mount Washington, a fashionable Los Angeles suburb. Gotesmani identified himself as the Marquis of Midjana, Provençal duellist, LaFayette descendant, and veteran of an African geographical expedition. (From GenealogyBank.com and published by NewsBank Inc.)

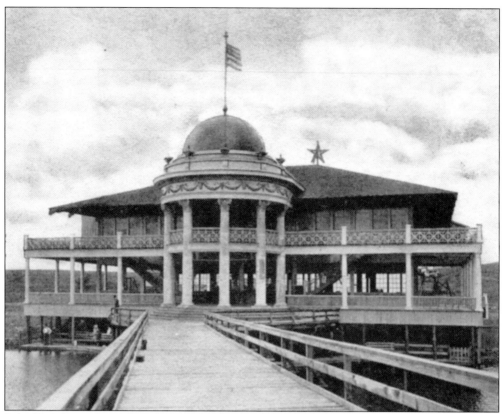

Lake Como's neoclassical pavilion wore a whimsical star. Architect Ludwig Bernhardt Weinmann designed the new structure, which drew thousands to its formal opening May 26, 1906. A new bathhouse, penny arcade, nickelodeon, shooting gallery, and other features enhanced the area. (Author's collection.)

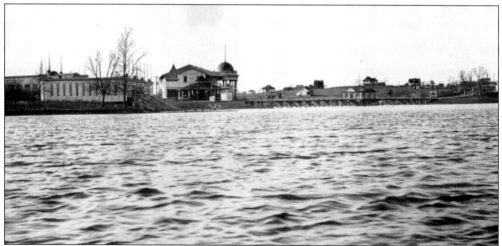

From a boat or from the opposite shore, Paddock brothers Arthur and Russell, who were South Siders, and their party photographed the Lake Como buildings across the gentle waves. Arthur would settle with his own family in Arlington Heights in the 1920s. (Courtesy of Dorothy Paddock Dixson.)

In searching the depths of Lake Como for a Heights woman's jewelry, Miss Pearl Gray would wear a regular diver's helmet "but not the remainder of the cumbrous diver's outfit, as the pressure of the water is not sufficient" as an advance newspaper item explained. The treasure is believed to have been stolen and, inexplicably, tossed into the water. The *Fort Worth Star-Telegram* carried the advertisement on September 19, 1915. (From GenealogyBank.com and published by NewsBank Inc.; courtesy of Dalton Hoffman.)

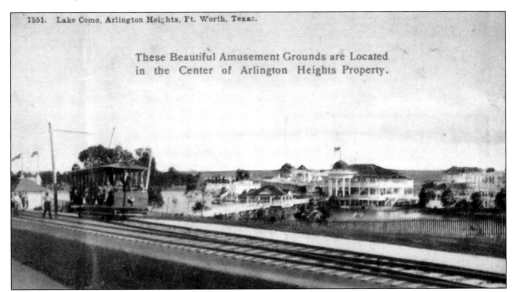

Managers of the private park added amusement rides and booked performers. Lake Como was a venue for society dances, classical concerts, labor union picnics, turkey shoots, fishing contests, fireworks displays, and a monkey speedway. (Courtesy of Gregory Dow of Dow Art Galleries.)

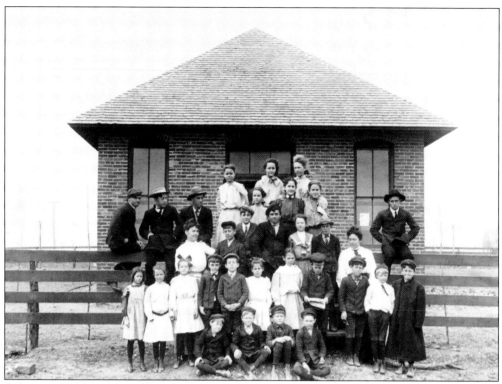

Arlington Heights' first public school opened in 1896 or 1897 and served neighborhood children for a decade. When a larger public school opened in 1909, the structure was sold as a residence. (Arlington Heights School, *c.* 1905, private collection, courtesy of the Amon Carter Museum.)

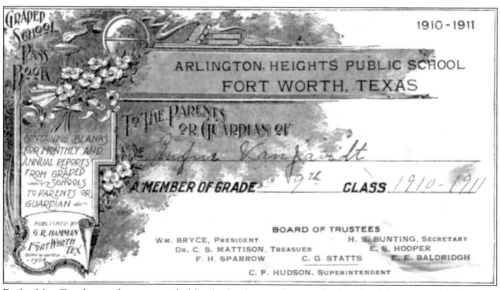

Rufus Van Zandt may have attended both the first and second schools of Arlington Heights. In 1916, he enrolled with the Texas National Guard at Camp Mabry in Austin and began its course of infantry instruction. (Courtesy of Dalton Hoffman.)

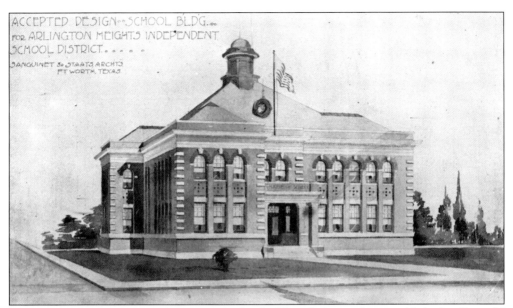

Sanguinet and Staats designed the second school, although the rendering published in *Beautiful Arlington Heights* differed from the completed building. Many years later, architects would top Arlington Heights High School and South Hi-Mount Elementary School with cupolas. (Courtesy of the Genealogy, History and Archives Unit, Fort Worth Public Library.)

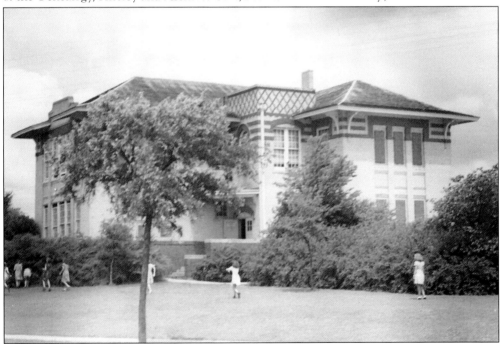

Arlington Heights Public School opened in 1909, with 300 students and their parents attending. A reporter wrote, "When the children raised their voices in song while the flag was being raised, the national airs could be heard for blocks." In the late 20th century, the Fort Worth Independent School District later trimmed off its generous eaves and spiral fire escape. (Courtesy of Billy W. Sills Center for Archives, Fort Worth Independent School District.)

It was for his daughter Madeline Roberta that Robert McCart wished to name the neighborhood. One addition (Roberta Heights) carried her name, as did part of present-day Trinity Park, but her lasting namesake was the residential street Madeline Place. Although she survived an automobile-wagon accident while visiting in Denver in 1907, she became ill later that year and died at the age of 21. (Courtesy of Alice Roberta McCart Walters and Roberta E. McAllister.)

Pianist Imogene Sanguinet, a 1907 graduate of Polytechnic College, also studied in New York and Berlin. Coloratura Ellen Beach Yaw invited her as accompanist on a 1908 performance tour. In 1911, she performed with the Russian Symphony Orchestra at the Byers Opera House; in 1912, she returned to the Byers stage in a memorial concert for her local mentor, Wilbur McDonald. A daughter of Marshall R. and Edna Sanguinet, she married investor and lender Frank Byrd Lary, was widowed in 1924, and married Robert E. Eagon of Dallas in 1925. Imogene, a mother of three, lived until 1952. (Courtesy of Alice Roberta McCart Walters and Roberta E. McAllister.)

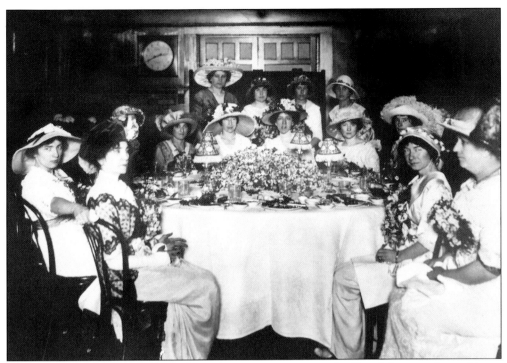

In 1913, Florence Gibson Baldridge hosted an engagement party for Flow Johnson at her residence on the corner of Arlington Heights Boulevard and Sanguinet Street. Her husband, cattleman and banker Earl E. Baldridge, later commissioned a larger mansion in the Heights. However, facing financial ruin, he committed suicide in a horse stall on the new estate in 1915. (Courtesy of the Amon Carter Museum.)

Mary Byers married Paul Jocelyn, moved to Minneapolis, and had a daughter. As did her friend Madeline McCart, she died at a young age in 1913. Her parents were Andrew Thomas Byers and Ida Harrington Bidwell Byers. (Courtesy of Alice Roberta McCart Walters and Roberta E. McAllister.)

Martha Redd Fontaine Flournoy, pictured as a bride in Tupelo, Mississippi, moved to Fort Worth with her husband, Robert Willis Flournoy, second owner of the Messer house. Both were descended from Virginia Huguenot colonial families, and she helped establish the local Mary Isham Keith Chapter of the Daughters of the American Revolution. (Courtesy of Nancy Fontaine Dangler Grasshoff.)

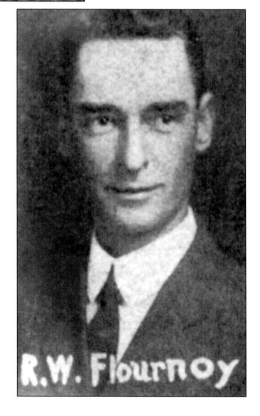

Attorney and law school professor Flournoy worked for flood prevention and professionalization of city government. He was the grandson of Robert Watkins Flournoy of Pontotoc, Mississippi, a Confederate veteran who acted on a dramatic change of heart during Reconstruction; the elder Flournoy advocated education for African Americans through his newspaper, *Equal Rights*, and as county school superintendent. When "disguised men" came after him, he and friends faced them, and a Klansman was killed. (Courtesy of the Tarrant County Bar Association.)

Resting on the back steps of the home, three-year-old Martha Fontaine Flournoy was the youngest of the Flournoy children. According to her daughter, Martha was often left to her own devices. (Courtesy of Nancy Fontaine Dangler Grasshoff.)

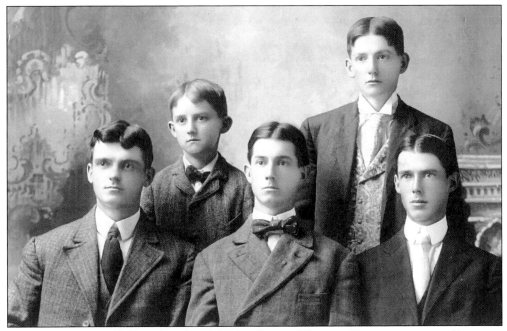

John Green Sims Jr. (left), gathered with his brothers in Wartrace, Tennessee, went to Princeton University, where he won the French Medal in debate. In 1902, he came to Fort Worth to found the Sims School for Boys, carrying the endorsement of his former professor, Woodrow Wilson. The school was east of Arlington Heights and across the river, yet Sims involved himself with the suburb's public school concerns. In addition, he authored numerous monographs on education. His wife and sometime fishing partner, Ethyl Turrentine Sims, established the Texas State Teachers' Association's first office in Fort Worth. (Family photograph courtesy of Allen W. Sims; medal photograph by Karl Thibodeaux.)

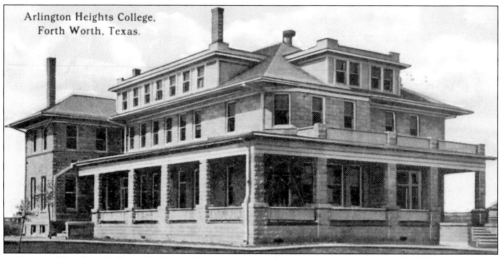

Arlington Heights College.
Forth Worth, Texas.

Arlington Heights College for Young Women opened in 1907 as a nonsectarian boarding school offering preparatory, intermediate, and college courses. The curriculum also included a travel study course, leading to a European tour. It was sold in 1915 and converted into a hospital with a special unit for treatment of pellagra patients. (Courtesy of Gregory Dow of Dow Art Galleries.)

ARLINGTON HEIGHTS SANITARIUM
(Incorporated Under the Laws of Texas.)

For Nervous Diseases **Selected Cases of Mental Diseases** **Drug and Alcohol Addictions**

P. O. Box 978, FORT WORTH, TEXAS.

A new and modern institution built especially for the homelike care and scientific treatment of its patients.

Separate buildings for male and female, comprising 40 rooms, heated by steam, lighted by electricity, and furnished with artesian water—hot and cold.

Patients under the care of specially trained nurses night and day.

The Sanitarium is located in beautiful Arlington Heights, 150 feet above and 5 miles from the city of Fort Worth, and within three blocks of Lake Como—the most popular pleasure resort in the vicinity—to which convalescent patients have access. Pure, fresh, invigorating air, sunshine and shade in abundance. Pleasant walks and drives.

A QUIET RETREAT, YET CONVENIENT TO CAR LINE AND CITY. INSTITUTION STRICTLY ETHICAL.

WILMER L. ALLISON, M. D.,
Supt. and Resident Physician.
For several years first assistant superintendent of Asylum at San Antonio.

BRUCE ALLISON, M. D.,
Resident Physician.
Formerly assistant physician of San Antonio Asylum.

JNO. S. TURNER, M. D.,
Consulting Physician.
Late superintendent of Terrell Asylum.

Chartered in 1906, Arlington Heights Sanitarium expanded the former home of Judge Joseph F. Cooper, who had left to serve on the Supreme Court of the Philippines. The Boyce-Sneed Feud began there in 1911 with a love triangle, resulting in killings and a courthouse hatpin fight. Farmers' Union organizer Owen Pinkney Pyle recovered from a breakdown at the facility and went on to found *The Progressive Farmer*. The display advertisement appeared in the *Texas State Journal of Medicine* in February 1912. (Courtesy of the Dolph Briscoe Center for American History, the University of Texas at Austin.)

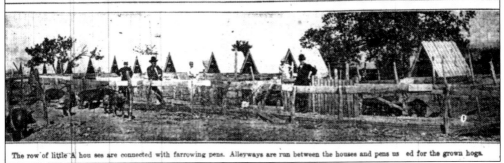

Community Hog Houses on Hill Crest Farm, Fort Worth

The row of little A hou ses are connected with farrowing pens. Alleyways are run between the houses and pens us ed for the grown hogs.

Fort Worth Stock Yards Company officer Owen W. Matthews bought 208 acres adjacent to Hi-Mount and reaching to the river and the White Settlement Road in 1907. His home was on Arlington Heights Boulevard; at a distance, he bred Duroc-Jersey, Poland-China, and Berkshire hogs at Hill Crest Farm. Featured in the *Fort Worth Star-Telegram* in 1914, Hill Crest was known for aristocratic stock "bred in the purple." Offspring of a famous boar, "Buddy K IV," lived there. Steeply pitched English cottage roofs appeared in the Hill Crest Addition after World War I, somewhat reminiscent (in angle) of Matthews' shelters. (From GenealogyBank.com and published by NewsBank Inc.)

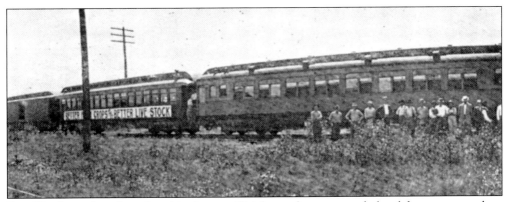

Fort Worth stockyards and packinghouse officials sought to persuade local farmers to produce high-quality, homegrown pork. When his Cotton Belt "squealer express" demonstration train stopped at Rusk in 1911, Matthews told farmers, "Nature gave you the greatest hint as to what this country was intended for when she put the wild hogs here that thrived in the hundreds of thousands, and when she saw that you had failed to take the hint she then sent the Bermuda." C. Wilbur Coons chronicled the railway campaign in "Boosting the Farmer's Game," published in *The Texas Magazine* in May 1911. (Courtesy of the Dolph Briscoe Center for American History, the University of Texas at Austin.)

Francis Zelichowski and his brother, William, emigrated from Gniewkwo, Poland, an ancient Slavic community. Their hometown was eventually Germanized and renamed Argeneau. The siblings came to Fort Worth from Central Texas. By the late 19th century, Frank was managing the Germania Hotel and Saloon, while William waited tables at another downtown spot. Both shortened and simplified the surname. As family members adapted to the new name, some spelled Zeloski with a Y. In the early 1900s, Frank acquired the above property in Arlington Heights. (Courtesy of Frost Bank.)

William Zelosky traveled to Chicago to visit the World's Columbian Exposition in 1893, stayed there and built a real estate empire; he connected with that city's Poles. Frank stayed in Fort Worth, where he invested in a brewery and real estate. He and his wife, Martha Kujawski Zeloski, moved their growing family from hotel rooms to Arlington Heights Boulevard, c. 1907. Frank identified with Fort Worth's German community. (Courtesy of Frost Bank.)

Rose Zelosky, daughter of Frank and Martha, was one of the first two women to earn law degrees from the University of Texas in 1914. She visited a Pennsylvania reformatory before managing legal matters for its Texas counterpart, and there "[she] became convinced that women's vote could correct conditions that make reformatories necessary." Rose joined AT&T as its first female legal staff member. (Published with permission of the Tarlton Law Library, Jamail Center for Legal Research, University of Texas School of Law.)

Rose Cecelia Zelosky, LL. B.
Fort Worth
Delta Delta Delta; Sidney Lanier; Newman Club; Vice - President Law Department; Vice-President Junior Laws; Vice-President Middle Laws.

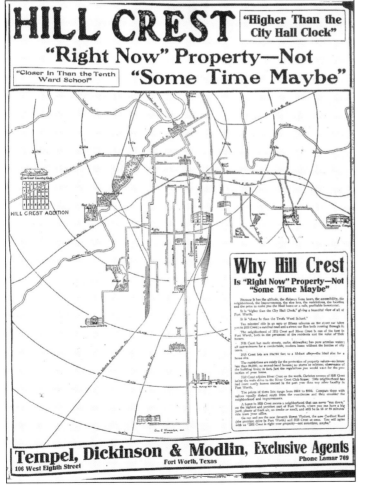

The Hill Crest Addition began after a local consortium purchased 160 acres of Chamberlin land from Alfred Crebbin, a British consular agent in Denver. They marketed with urgency in their advertising language of 1914 in the *Fort Worth Star-Telegram*; the fine print included details about restrictions (no saloons, stores, or second-hand buildings) and assurance that "a house in Hill Crest means a neighborhood that can never 'run down.'" (From GenealogyBank.com and published by NewsBank Inc.)

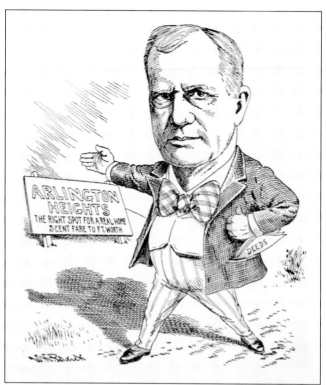

Caricatured by W. K. Patrick for the insiders' edition of the book *Makers of Fort Worth*, James Stanley Handford campaigned extravagantly to sell a neighborhood as president of Arlington Heights Realty Company. In Batesville, Arkansas, he was a wholesale grocer and bank officer. (Courtesy of the Amon Carter Museum.)

ge, barn and od Heights; . See owner t Worth.

RLINGTON

500 feet, east , hardwood om, chicken ideal resi-ice price on the city. Fa-

t,

T.

d home?

every way,

avenue. Call Lamar 2??L

JENNINGS AVE.—For sale by owner, 1½ blocks south of Magnolia, No. 1410. b extra large rooms, also attic, east front, fine lawn, lot 50x164; all modern conveniences. Come and look a' it and ask for price and terms. Phones La-mar 6056 and 6052 and new 1414.

FOR SALE—By owner, modern 5-room cottage. 600 E. 2d st. Inquire within.

LOT in Arlington Heights to trade for a good typewriter. Address A, care Star-Telegram office.

$50 down, balance like rent, neat 3-room house. Polytechnic Heights, routh front, smooth lot. Phone Lamar 1707.

FOR SALE—Lots 152 and 153 in Val-ley View addition No. 2, $140 cash gets them. Lamar 7136. L. E. Young.

FOR SALE OR TRADE—New 5-room house, on south side, 1 block of Hemp-

we have medium-price property. We have Riverside an acreage prop trade for pr Just call u mar 7233. O if you have a to rent. Here are a A fine bus located, 100x Lot 110x20 Delaware bot 87½x95 nor lots), $21,000. Lot on Thr Business p $13,600. Several go Main, one $1 at $27,500.

Whether placed in jest or in desperation, the classified advertisement appeared in the *Fort Worth Star-Telegram* on June 5, 1910, and became the subject of folklore. Other ads proposing barter for Arlington Heights property also ran during the period of slow development. (From GenealogyBank. com and published by NewsBank Inc.)

Four

The Great War
on the Prairie

Hosting a City of Soldiers

1917–1919

It seems a singularly fortunate, or most probably deliberate, choice in the location of Camp Bowie that the topography around this camp is the same type of topography found along much of the Western Front, and that the underlying rocks are similar, in geologic age, in hardness and texture, and in the kind of fossil life entombed within, to those to be seen along the Marne, around Lens, Vimy, Arras, and others of the hard fought battlefields of France.

—Ellis W. Shuler, "The Geology of Camp Bowie and Vicinity,"
University of Texas Bulletin N0. 1750, September 5, 1917

Most of the plums marketed to prospective residents of Arlington Heights had gone unpicked, but business and civic leaders, including developers, saw a unique opportunity as the United States mobilized for late participation in World War I. Ben E. Keith, president of the Fort Worth Chamber of Commerce, Robert McCart, and others launched a campaign to offer the land to the U.S. Army for use as a training camp.

Although the suburb was nine years away from annexation, Fort Worth officials pledged to connect the camp's water system to the city's Fort Worth Power, Light, and Gas. County commissioners promised to provide road improvements. Fire and police services would be provided. The army leased a huge tract of land for five years, and newspaper items in 1917 carried speculation of a permanent facility.

Camp Bowie filled in the vacant spaces of the neighborhood. For a brief period, a population of unprecedented diversity inhabited its tents and barracks.

At war's end, Camp Bowie was designated as a general demobilization center; thousands more soldiers reported for the mustering-out process. The soldiers were not forgotten. A neighborhood park was created in their honor, near the site of division headquarters. Memorial trees were planted. Members of one neighborhood congregation rededicated their institution as Soldiers' Memorial Baptist Church. Respondents to a newspaper solicitation to rename the main road included a young girl who sent in the suggestion "Hun's Defeat Boulevard." Camp Bowie Boulevard won.

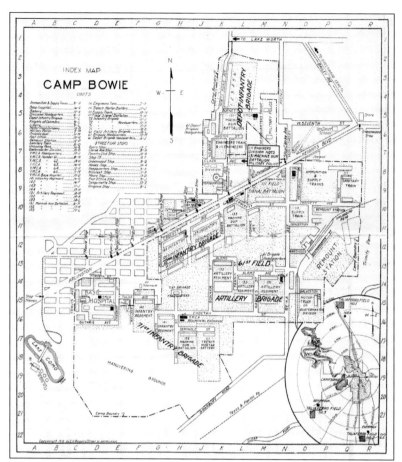

C. H. Rogers's hand-drawn map of 1918 made clear the locations of Camp Bowie's facilities. For an exhibition on the camp presented by the Fort Worth Museum of Science and History, an overlay version of the map was created so that visitors could see street-name and route changes and determine what once occupied present-day areas. (Courtesy of Pete Charlton.)

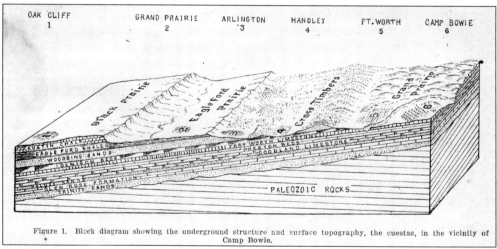

Figure 1. Block diagram showing the underground structure and surface topography, the cuestas, in the vicinity of Camp Bowie.

Geologist Ellis W. Shuler illustrated his 1917 study of Arlington Heights with this "block diagram showing the underground structure and surface topography, the cuestas, in Camp Bowie." Shuler, formerly at Polytechnic College, had by 1917 joined the Southern Methodist University faculty. He took the assignment to assess an area the U.S. Army was considering for a training camp. (Courtesy of the Dolph Briscoe Center for American History, the University of Texas at Austin.)

Natives of Lyon, France, Jeanne Francoise Durhone Bideault and her husband, Anthelme Bideault, with five of their eight U.S.-born children, Belle, Henrietta, Laurie, Blanche, and Pierre, toured Camp Bowie's practice trenches in 1918. At their farm near Bransford (now within Colleyville), they extended hospitality to French officers stationed at Camp Bowie; the home still stands, bearing a Texas Historical Marker. (Courtesy of Tarrant County College Northeast, Heritage Room, Hurst, Texas.)

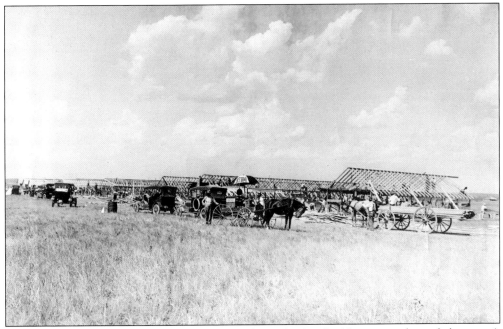

The massive and rapid construction of barracks and other buildings transformed the camp's 2,186 acres west of Fort Worth, where Maj. Gen. Edwin St. John Greble commanded the Army's 36th Infantry Division. Construction began July 18, 1917. (Courtesy of the Texas Military Forces Museum, Camp Mabry, Austin, Texas.)

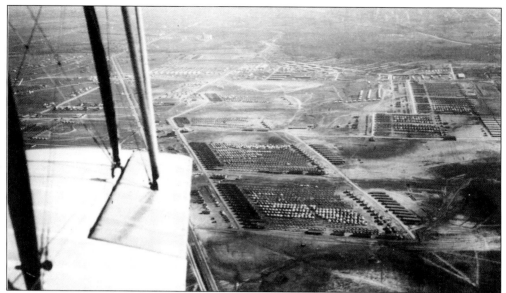

An aerial view captured the sweep of Camp Bowie's land coverage and the regimented layout of its tents and other structures. (Courtesy of David Pearson.)

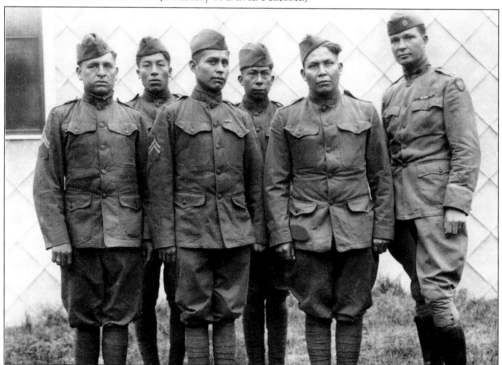

All members of the Choctaw Telephone Squad began their initial training at Camp Bowie, later reporting to Camp Merritt, New Jersey. They are pictured as following: (left to right) Pvt. James Davenport, Corp. James Edwards, Corp. Calvin Wilson, Pvt. Mitchell Bobbs, Pvt. Joseph H. Davenport, and their commanding officer, Capt. E. H. Horner. These men were predecessors of the Navajo Code Talkers of World War II. (Courtesy of the Wanamaker Collection, Mathers Museum of World Cultures, Indiana University.)

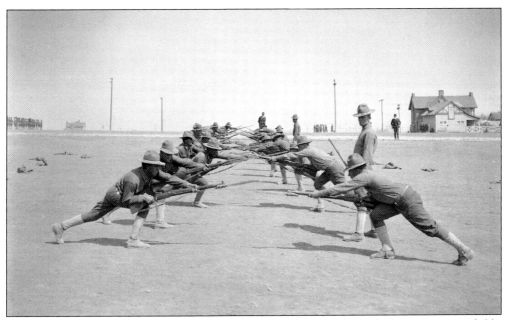

Bayonet practice brought stark symmetry and combat choreography to the barren practice fields. (Courtesy of the National Archives.)

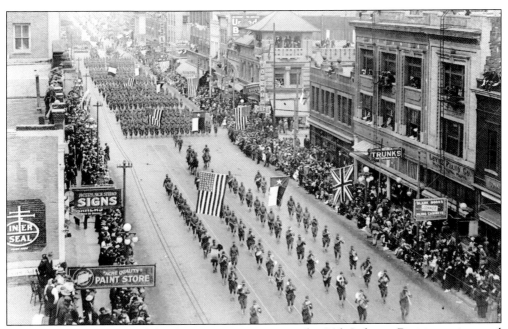

Some 225,000 people lined the downtown streets to see the 36th Infantry Division as it passed through the streets of downtown on April 11, 1918. U.S., French, British, and Texas colors fluttered high overhead. (Courtesy of the Texas Military Forces Museum, Camp Mabry, Austin, Texas.)

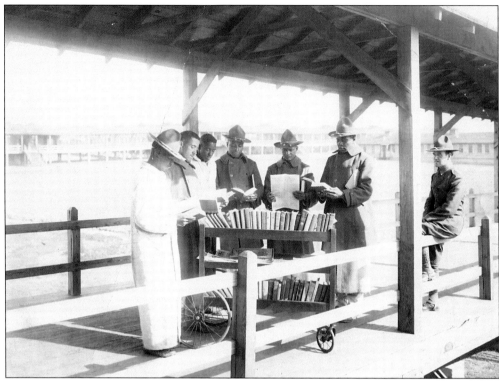

African American soldiers, patients housed in a separate ward at Camp Bowie's hospital, browsed the book cart from the camp's American Library Association library. Segregation persisted in all aspects of camp life. (Courtesy of Dalton Hoffman.)

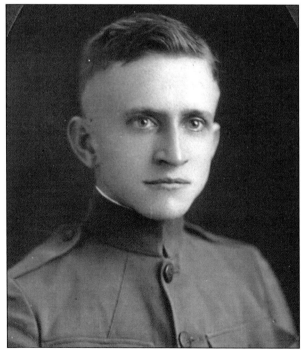

Russell Paddock enlisted in his hometown of Fort Worth and reported to Camp Bowie, then contracted influenza and died in the base hospital before he could complete his training and make the crossing to France. His father, Ira Paddock, asked to bring the family physician into camp to examine him, but quarantine rules were enforced and neither the father nor the doctor could go in. (Courtesy of Dorothy Paddock Dixson.)

Fredelia L. Dixon of the Army Nurse Corps was chief nurse at the base hospital. Born in Corsicana and raised in Iowa, she had taught, trained as a nurse, worked in hospital surgeries, and served as a school nurse before the war began. She came to Camp Bowie assignment from Camp Travis in San Antonio. (Courtesy of Ben Guttery.)

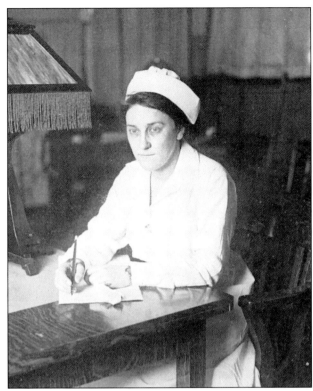

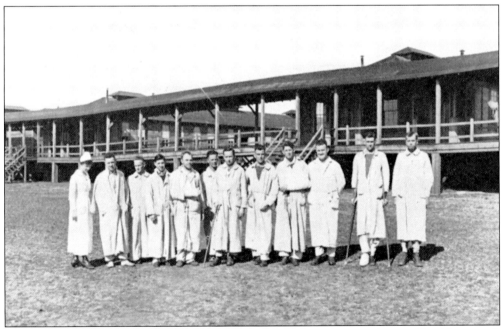

Patients stepped out for sun. Capt. J. Earl Alexander, author of a camp hospital booklet, noted, "When we . . . consider the marble corridors . . . to which we have become accustomed, a description of a ward would seem . . . ridiculous. However, the picture of a ward of this temporary hospital from within or without is pleasing." (Courtesy of Ben Guttery.)

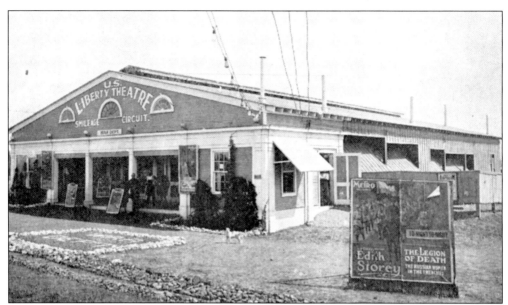

Although programming was carefully censored, Liberty Theatres brought many films to Camp Bowie and other camps, keeping the reels moving along the "smileage circuit" for morale's sake. Only films that would uplift the soldiers' spirits were to be screened. Other organizations showed films, too, notably the YMCA. (Courtesy of Dalton Hoffman.)

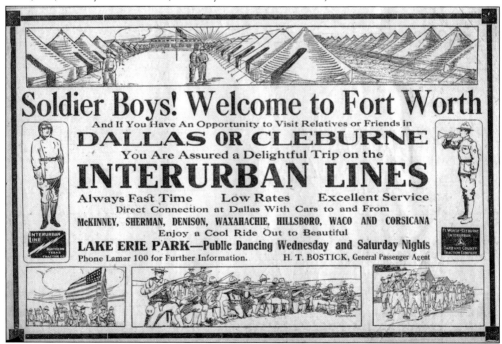

Local newspapers carried hard-to-miss invitations to Lake Erie, but Camp Bowie was adjacent to Lake Como and closer to Lake Worth. Kansas "carnival device king" Charles Wallace Parker revitalized Lake Como with new amusements in 1917, as he did other parks near military installations. "Joy Land" was also established on Van Zandt farmland east of the camp. (Courtesy of Dalton Hoffman and Pete Charlton.)

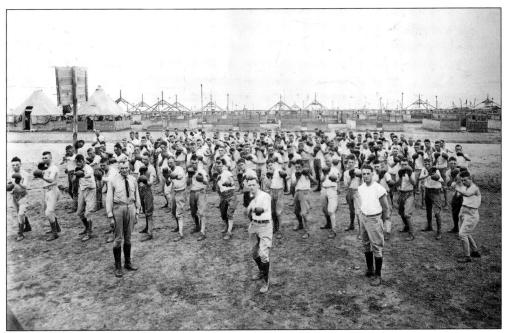

Boxers, sponsored and trained by the YMCA, approached the camera as tent frameworks went up behind them. In *Making Men Moral: Social Engineering During the Great War*, Nancy K. Bristow quoted reformers of the period on boxing's usefulness, which was often proclaimed to be a good way to prepare men for combat and bayonet fighting. (Courtesy of the Kautz Family YMCA Archive, Special Collections and Rare Books, the University of Minnesota.)

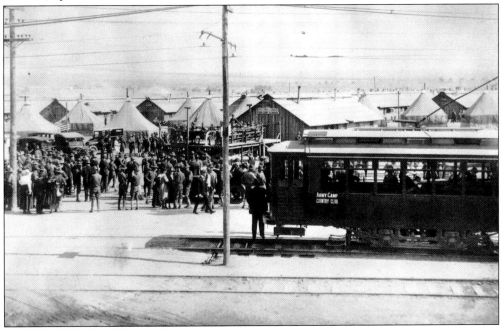

Sundays at Camp Bowie kept the streetcars running. The Commission on Training Camp Activities (CTCA), headed by reformer Raymond B. Fosdick, was especially concerned about the temptations soldiers would encounter outside the camp boundaries. (Courtesy of Dalton Hoffman.)

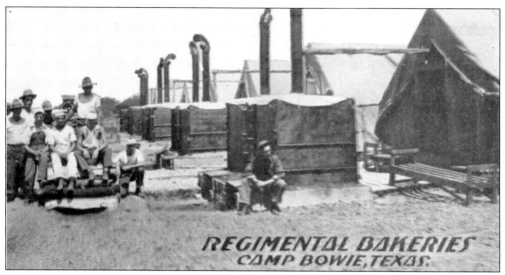

During the war, camp quartermasters could not send out for commercially baked bread. All bread consumed was baked at the site. According to a contemporary online source, *The Seabee Cook*, the army's 123-page *Manual for Army Bakers* (1916 edition) is a useful book for the 21st century. (Courtesy of Dalton Hoffman.)

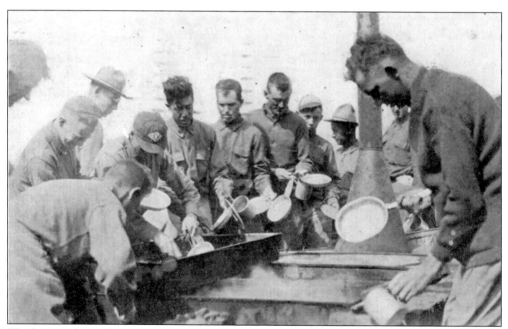

"Each man cleans his own plate," postcard recipients would read of this Camp Bowie scene. Outdoor dining could be hazardous; mess kits, cooks' pans, and barbed wire around the stockade were thought to have drawn three lightning bolts down on 15 soldiers one July evening in 1918. Two died. (Author's collection.)

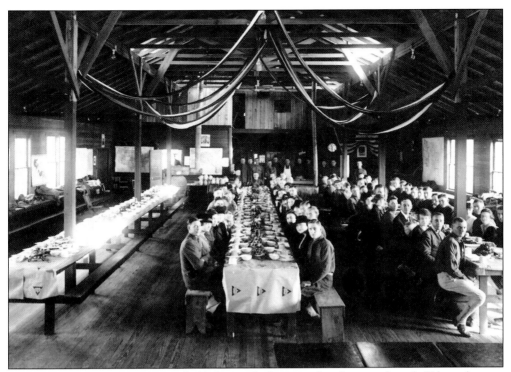

Soldiers dined in the YMCA hall, beneath festooned rafters and with Y-logo linens. (Courtesy of the Kautz Family YMCA Archive, Special Collections and Rare Books, the University of Minnesota.)

John Nathan White of Arkansas and East Texas trained in the 133rd Machine Gun Battalion, Company C, 36th Division, and served in France. "Being at Camp Bowie made Fort Worth his favorite place to settle after the war," noted his son, Jack White; "that's why I'm a Fort Worther." Jack created and moderates an online photographic history exchange, and he posts vintage images on "Architecture in Fort Worth" (www.fortwortharchitecture.com), the Web site of architect John Roberts. (Courtesy of the Jack White Collection, Special Collections, the University of Texas at Arlington.)

53

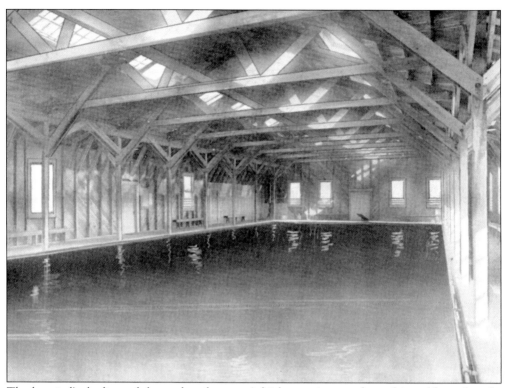

The hospital's sky-lit pool, located at the camp's highest point, was heated in cold weather. Its 135,000 gallons of water were available to extinguish a fire and could be drained when the space was needed for a large auditorium. This was done for Billy Sunday, the "muscular evangelist" who delivered his sermon from the diving board. (Courtesy of Ben Guttery.)

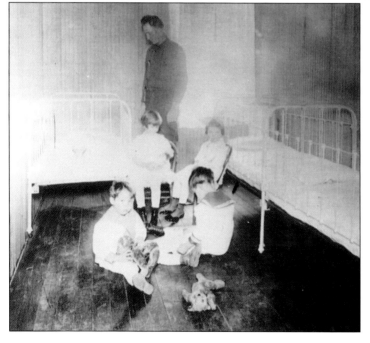

An austere corner of Camp Bowie's YWCA Hostess House was set-aside for children and childcare. As Nancy K. Bristow explained in *Making Men Moral*, Hostess Houses provided safe places for military men and civilian women to meet, and also offered meals, a homelike atmosphere, and supervised recreation in cooperation with the federal government's Commission on Training Camp Activities. (Courtesy of the National Archives.)

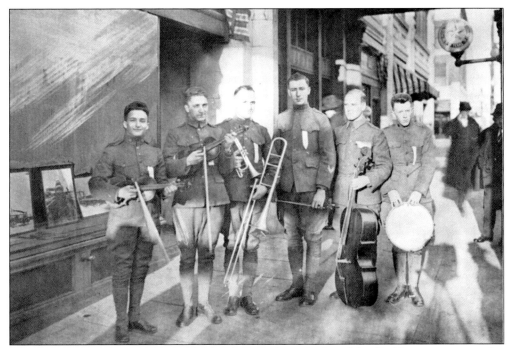

The Bowie Jazz Band was in demand for receptions, a dance for Gen. John Greble, camp commander, Rivercrest Country Club, Taliaferro Gymkhana, Red Cross, Knights of Columbus, Jewish Welfare Board, and a convention in Tulsa. Miller's Jazz Phiends, formed earlier, also played at the camp and surrounding airfields. (Courtesy of Ben Guttery.)

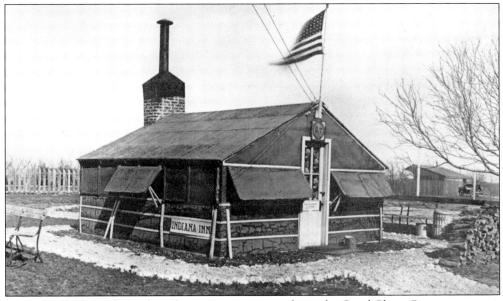

Capt. J. Earl Alexander's refuge "has no connection with . . . the Good Cheer Cottage . . . nor is it supported by the Righteous Reformers of the Awful Army," he wrote. With a Victrola, fireplace, willow furniture, and sports equipment, it had "everything essential to a man's happiness with the exception of the Elusive Fluid, John Barleycorn," he wrote in *The Capsule*, the base hospital souvenir booklet. (Courtesy of Ben Guttery.)

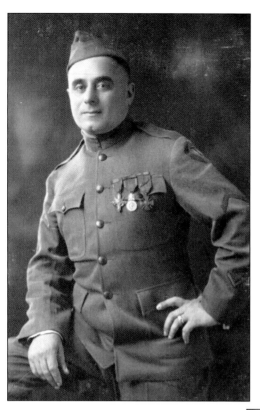

Sgt. Sam Dreben brought experience to Camp Bowie; the Russian Jewish immigrant had already fought in several conflicts. For heroism at St. Etienne with the 141st Infantry Regiment, he received the French *Medaille Militaire*, among other decorations. In 1921, Gen. John J. Pershing invited him to help escort the Unknown Soldier to Arlington Cemetery. Damon Runyon praised him in a 1922 poem, "The Fighting Jew." (Courtesy of the Calleros Collection, El Paso Public Library.)

Col. Arthur Albert Messer, D.S.O., C.B.E. (left), who had returned to England from Texas in 1898, volunteered with the British Red Cross during World War I, providing his own vehicle. From 1915, and after the Armistice, he assisted Fabian Ware (right), first director of the Imperial War Graves Commission. As Philip Longworth noted in *The Unending Vigil: The History of the Commonwealth War Graves Commission*, the architect designed war memorials in Switzerland, the Netherlands, and the Scandinavian countries. He also created a legacy of residential, church, chapel, and clubhouse design in England. Widowed for years, Arthur married Lillian Hope (Lilla) Dowling in 1924; they had two children. He died in 1934. (Courtesy of Cholmeley J. Messer.)

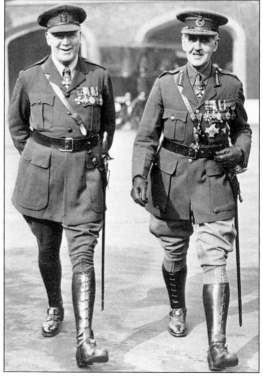

Five

ATOP A WARTIME INFRASTRUCTURE

BUNGALOWS AND COTTAGES

1919–1941

Out on the terrace, Lucille and I leaned on the ledge and watched the lights. They spread out fanwise before us, like skeins of yellow stars flung down riotously over the dark shoulder of the prairie. She was standing in front of me. Very close. We were pleased to be inquisitive as to the status quo behind the glimmering lights, and she pointed suddenly. "A plumber lives there," she announced. "He lost two fingers in the battle of the Marne, and Agatha, his wife, is big with child as she sleeps beside him."

—Philip Atlee, *The Inheritors* (New York: The Dial Press, 1940)

Young moderns speculated on bourgeois life in James Young Phillips's *roman à clef*. Cognizant of another world adjacent to theirs, they considered it from a vantage point near the top of their city's tallest hotel. In translation, they lived in the wealthy Rivercrest area and had access to a lofty suite at the Blackstone Hotel downtown. From their perch, they surveyed Arlington Heights.

By the time The Dial Press published Phillips's locally controversial pseudonymous novel, the house building that began in 1919 was almost complete. Arlington Heights encompassed mostly middle-class dwellings.

The unfinished business of 1889–1917 had, post-Armistice, resumed in 1919. Builders went to work even as the army dismantled Camp Bowie. One realtor established headquarters in its unpainted library, and army utility connections saved developers trouble and expense.

New mansions arose in Northcrest and along Strathmoor's gracefully curving Tulsa Way; other areas took on a "sawmill suburb" appearance, but with variations on basic designs. Hill Crest filled with brick-veneer and siding-clad residences reflecting architectural influences from English Tudor to Colonial to California Bungalow. Here and there, resourceful residents adapted Camp Bowie buildings and materials to create their homes.

The built environment gained more community structures in the 1920s: a fraternal lodge, houses of worship, storefronts, service stations, and a second country club.

Just ten years after the start of the cottage-and-bungalow boom, Arlington Heights residents faced an unprecedented obstacle course. The Depression sent the wolf to the door of many houses. Then came the next Great War.

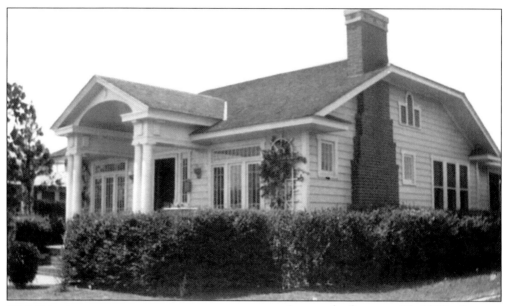

Among the first post–World War I homes built on Hillcrest Avenue was a classic bungalow. Several families lived there, but the Hailey family has remained for three generations, restoring and enhancing over the years. Christopher Hailey, retired exhibits artist for the Fort Worth Museum of Science and History, created the 1996 multimedia exhibition *Over Here: Camp Bowie, Fort Worth, Texas, 1917-1919*. Author John Graves grew up next door. "On the corner of Hillcrest and Bryce Avenue, a couple of houses south of us," Graves reminisced, "lived our family physician Shelton Barcus with his wife and daughter, plus his brother-in-law Joseph White, a respected surgeon and a wise reader of English literature, who could quote Shakespeare and the King James and many poets humorously in conversation—a notable factor, I think, in my subsequent interest in writing." (Photographs c. 1930 by Warren Weldon and courtesy of Christopher and Linda Hailey.)

Hill Crest had been planned and platted a few years prior to World War I, but a new 1919 map was drawn up in anticipation of the postwar rush to build. The framed blueprint version hung for decades in the office of Ben Eastman's Hill Crest service station. (Courtesy of Ben Eastman Jr.)

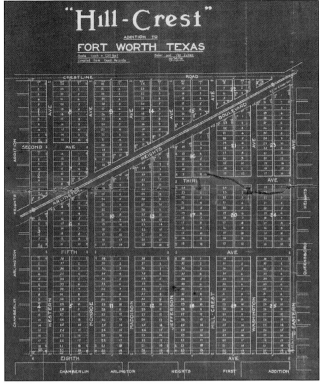

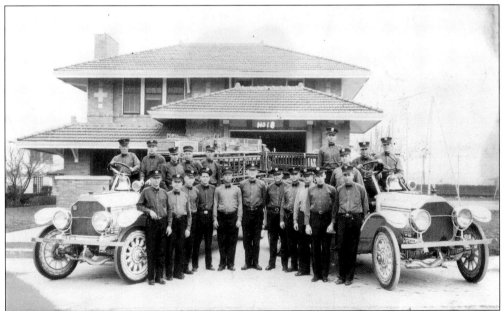

Arlington Heights Fire Station No. 18 on Carleton Avenue was one of several local bungalow stations. Masons laid the cornerstone in 1923, the year of their own lodge construction program a block away. By 2005, it had become the city's oldest functioning fire station. Western swing musician Roy Lee Brown started there in early 1960s as an engineer and driver. (Courtesy of the family of the late Battalion Chief Jim Noah.)

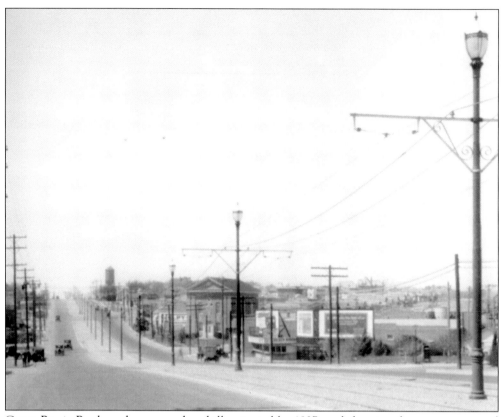

Camp Bowie Boulevard was paved and illuminated by 1927, and the view from streetcars and automobiles included landmarks such as the Masonic lodge (center) and several commercial rows. (Courtesy of the Genealogy, History and Archives Unit, Fort Worth Public Library.)

Lory and Bayard Friedman, siblings of Barbara Friedman and children of Harry and Mayme Potishman Friedman, at play on the lawn of their home on Bryce Avenue, could gaze across at the rooftops of the McCart mansion beyond the foliage. Barbara became an architect; Lory an artist and photographer; and Bayard a banker and mayor of Fort Worth. (Courtesy of Lory Friedman Goggins.)

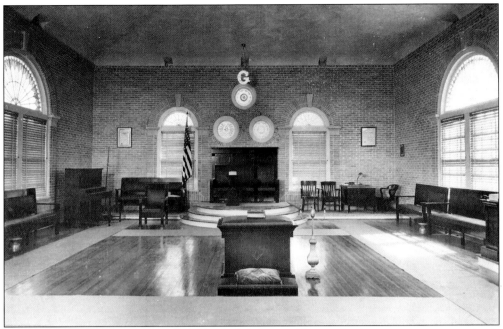

The home of the Arlington Heights Masonic Lodge would be no brick-veneer structure; its brick interior was faced with a brick exterior. Advocates of this choice prevailed, though the $20,000 expenditure sparked controversy. Members were so moved to hold meetings in the structure before it was completed that they climbed a ladder to the upper level. Spittoons were strategically placed. (Courtesy of Arlington Heights Masonic Lodge No. 1184, A.F. & A.M.)

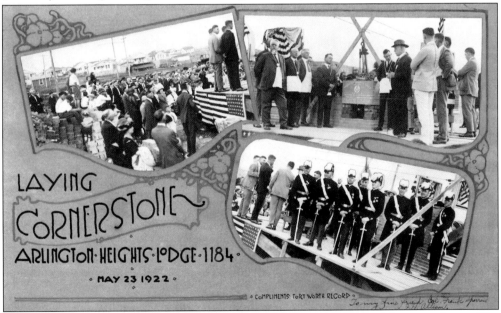

"The stone was sprinkled with the corn of plenty, the oil of contentment and the wine of joy . . . The charge delivered to the architect was to build the building as per the requirements of the order to bless mankind." Concluding at sunset, the cornerstone setting drew a crowd on May 23, 1922. (Courtesy of Arlington Heights Masonic Lodge No. 1184, A.F. & A.M.)

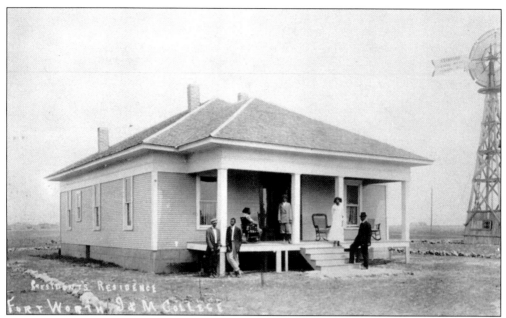

The Baptist Missionary and Educational Convention moved the former Hearne Academy to Lake Como in 1909 and renamed it Fort Worth Industrial and Mechanical College, attracting African American students from within and outside the area. It operated for 20 years. Major J. Johnson served as first president of the relocated institution. (Courtesy of the Tarrant County Black Historical and Genealogical Collection, Fort Worth Public Library.)

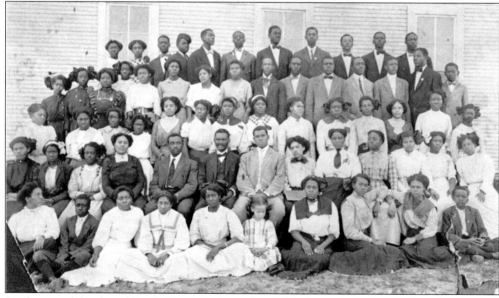

Students and faculty of Forth Worth Industrial and Mechanical College gathered in 1919. It never provided college-level studies "for lack of funding, personnel, or other obstacles," noted Michael R. Heintze in *The Handbook of Texas*. One campus building later housed Zion Missionary Baptist Church. The Chamberlins had planned to start a college in Arlington Heights, but a Northern Methodist Episcopal bishop insisted that African Americans be admitted, which ended negotiations. (Courtesy of the Tarrant County Archives.)

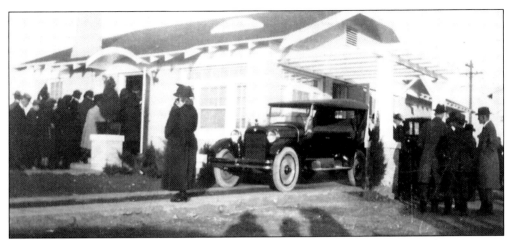

Six thousand people toured the *Fort Worth Star-Telegram* "Home Beautiful" on Clover Lane in the Crestmont Addition on Sunday, December 10, 1922. Local suppliers and crafts persons had outfitted it with every convenience and furnished it completely. The Agee Screen Company, in its promotion, guaranteed "to keep the flies out." The high bidder was Mel Shugert, a Sinclair Oil employee who needed to move with his wife and three children from Ranger to Fort Worth. (Photograph by Venus Baker and courtesy of Barbara Baker.)

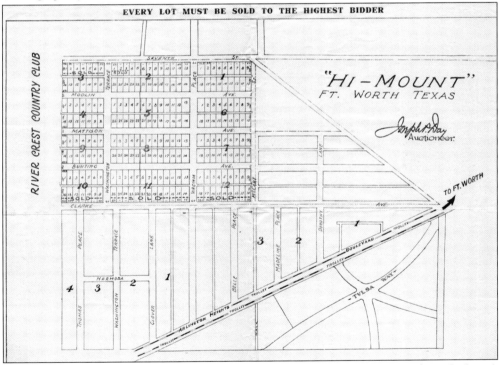

Early in the century, developers of Hi-Mount had opened a residential section similar to St. Louis's "place" enclaves. However, a 1921 brochure indicated persistent vacancies; many smaller lots had been platted, and auctioneers distributed flyers to attract bidders at bottom prices. Among selling points: "The Women's Federated Clubs have planted one thousand trees along the adjoining boulevard and throughout Hi-Mount, thereby assuring shade and beauty to the locality." (Courtesy of Pete Charlton.)

Harry B. Friedman, engineer and builder, came to Fort Worth after World War I with a degree from the University of Cincinnati, experience, and talent. Although known for the Sinclair Building and other masterworks, he took on smaller projects in Arlington Heights, including the enduring Hi-Mount School and Zeloski commercial rows. Friedman always wore a hat and dressed well, even at construction sites, recalled his daughters, Barbara Friedman and Lory Friedman Goggins. (Courtesy of Lory Friedman Goggins.)

Hi-Mount School on LaFayette Street, designed for the Arlington Heights school district by Wiley G. Clarkson and A. W. Gaines and built in 1921–1922, originally compressed first through sixth grades into its four classrooms. It was later renamed Thomas Place Elementary, after two nearby schools were given Hi-Mount suffixes, and converted to a three-grade school. (Courtesy of the Billy W. Sills Center for Archives, Fort Worth Independent School District.)

Pat and Carl Hoera Sr., with Carl's father, Charles (center), and their children, Jean and Carl Jr., stood on the front porch of their home, purchased in 1922. The builder of the elaborately detailed red-and-white bungalow on Hillcrest Avenue was likely Meredith Carb. (Courtesy of Susan Hoera Toppin.)

Carl Hoera Jr., attended Hi-Mount Elementary School, a block away from his home on Hillcrest Avenue. Although small in size and student numbers, Hi-Mount offered opportunities; Carl joined its playground baseball team and helped win the city championship in 1932. (Courtesy of Susan Hoera Toppin.)

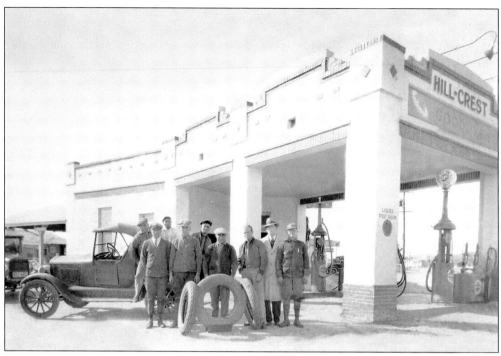

Ben Eastman's Hill Crest Service opened in style at a prime location in 1922. Eastman, with an enthusiasm for marketing and a gift for keeping loyal customers, built up a clientele so large he eventually had 22 or more employees on hand. (Courtesy of Ben Eastman Jr., and Gordon Eastman.)

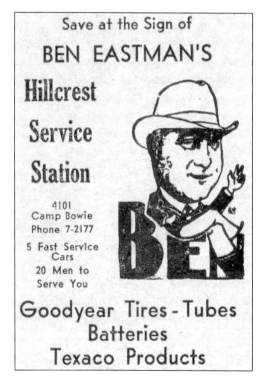

Eastman "was strictly a businessman who ended up running a service station. He wore a suit and tie and vest to work every day and never touched a gas pump handle," recalled Ben Jr. "He would talk to the customers as they were being waited on and made great friends, such as Amon Carter and other well-known people, and would have a picnic at our farm every year for around 350 people." C. W. Spears, head coach at Dartmouth College, wrote in 1919 that Ben was "a clean liver and a hard worker . . . [who possesses] the power of leadership and of inspiring confidence in men." (Courtesy of Billy W. Sills Center for Archives, Fort Worth independent School District.)

Edna Staats (top right), a daughter of the architect Carl Staats, attended LaSalle University in Philadelphia. At a LaSalle-Dartmouth College dance, Edna met Ben, a native of Fort Ann, New York, who played football for Dartmouth. He served in the U.S. Navy during World War I. Afterwards, "Dad looked my mother up, came to Fort Worth, and it was history from then on," Ben Jr. said. They wed on February 4, 1922; Marguerite Scaling and Helen Haltom were among the attendants. (From GenealogyBank.com and published by NewsBank Inc.)

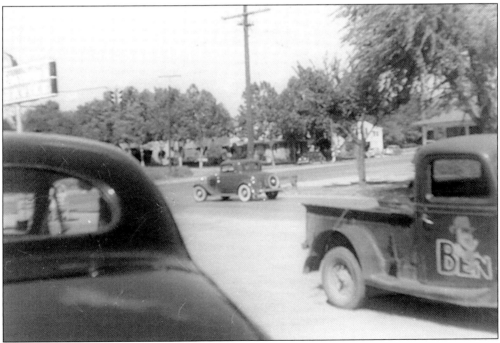

The BEN logo advertised as it traveled. Eastman's fleet of service trucks rolled down the boulevard and other streets within and outside the neighborhood. The station's list of regular customers included many in other sections of Fort Worth, business travelers, a bus company, and residents of Aledo and Kennedale. (Courtesy of Ben Eastman Jr.)

Brothers Milton, Roy Lee, and Derwood Brown (left to right), children of Annie and Barty Lee Brown, grew up immersed in music at their home on D'Arcy Avenue, which was built with lumber from a Camp Bowie barracks building. Barty walked to and from work at the Bain Peanut Company and fiddled for house dances. During the bricking of Camp Bowie Boulevard, Roy Lee would climb aboard idle motorized paving rollers at night, pretending to operate them. (Courtesy of Roy Lee and Ellen Brown.)

Milton (far left) took a break with fellow Arlington Heights High cagers in 1925. Milton Brown and his Musical Brownies brought forth western swing, merging twin fiddles, amplified steel guitar, jazz piano, slapping bass, and improvisation with country music. After Milton's fatal car crash in 1936, his brothers carried on. Roy Lee became a firefighter and built a house on D'Arcy for his own family. He and Milton are Texas Western Swing Hall of Fame inductees. (Courtesy of Roy Lee and Ellen Brown.)

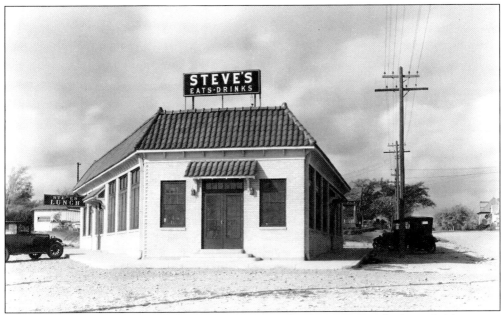

Stephen Murrin, son of an Irish immigrant who rose to local prominence, had sampled four types of work before launching his Arlington Heights restaurant: selling periodicals, delivering clothing, being a cowboy, and operating a downtown chili parlor. As Ty Cashion noted in *The New Frontier: A Contemporary History of Fort Worth and Tarrant County*, the land Murrin bought at the end of the trolley line was shaped like a piece of pie. (Courtesy of Susan Murrin Pritchett.)

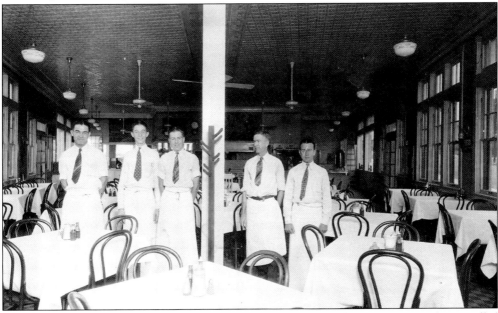

Steve's opened in 1927 and offered curb service in its early years. A former teenage carhop recalled toting many ham sandwiches to customers parked in the head-in slots. As Renfro's Triangle/Banquet Room, Duncan's Cafeteria, Finley's Cafeteria, the Black-Eyed Pea, and Lucile's Stateside Bistro, the place still called "Steve's" in sidewalk tile work has fed generations. Murrin (fourth from left) stood with his waiters in the heart of the restaurant. (Courtesy of Susan Murrin Pritchett.)

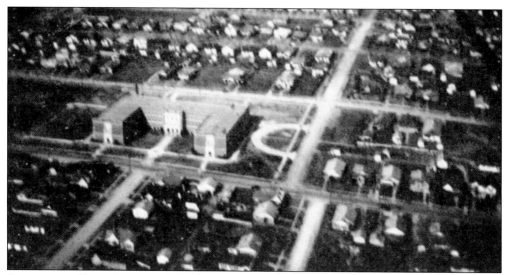

Opening on Clover Lane in 1928, the W. C. Stripling Senior High School replaced the first Arlington Heights High School on Camp Bowie Boulevard after only a few years. As with several Fort Worth schools, it was named in honor of a prominent merchant, and W. C. donated funds for landscaping the campus. (Courtesy of the Billy W. Sills Center for Archives, Fort Worth Independent School District.)

Just outside the gymnasium at Stripling, the John Locke translation of Roman poet Juvenal's words "a sound mind in a sound body" signaled that physical fitness was essential to learning. On the façade of the auditorium, engravers quoted from Republic of Texas President Mirabeau Buonaparte Lamar, a public education advocate: "Cultivated mind is the guardian genius of democracy." (Courtesy of the Billy W. Sills Center for Archives, Fort Worth Independent School District.)

On the lawn of the Stripling campus, members of the STAG Club tinkered with their scale models of Fort Worth landmarks and a miniature layout of Burk Burnett Park. Aspiring designers grew up in a neighborhood already rich in architects and builders. Editors of the 1937 *Yellow Jacket* did not explain the club's acronym. (Courtesy of the Billy W. Sills Center for Archives, Fort Worth Independent School District.)

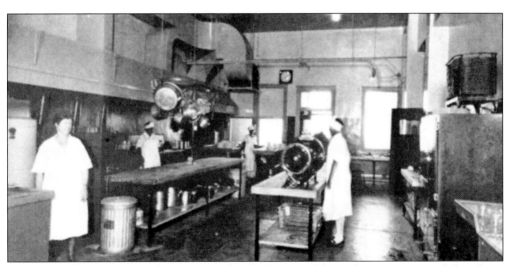

When Stripling was new, the 1928 yearbook editors celebrated every corner of the place, including the kitchen. Mrs. Hoskins, in charge (left foreground), was the only staff member identified by surname. Working with her were cooks Dora, Susie, and Willie. (Courtesy of Beth Phillips Engelhardt.)

Poet Maud Chandler Modlin commented on suffrage in a 1921 *Fort Worth Star-Telegram* series: "Woman . . . has often revolted, though sometimes not openly, against a custom that seemed to shackle her mind and soul." Maud had studied at the Sargent Academy of Dramatic Arts in New York. Her affiliations included American Penwomen, Fort Worth Little Theater, and Arlington Heights Methodist Church. She also became a minister in the Light of Truth Spiritualist Church. (Author's collection.)

The home of Delbert O. and Maud Modlin on Tremont Avenue included many special California bungalow features inside, according to Patricia Collins Massad, whose parents purchased it in the late 1930s. The couple came from Xenia, Illinois; he was a partner in the real estate firm Tempel, Dickinson, and Modlin, and won praise for helping persuade the army to locate its World War I training camp in Arlington Heights. (Courtesy of Patricia Collins Massad.)

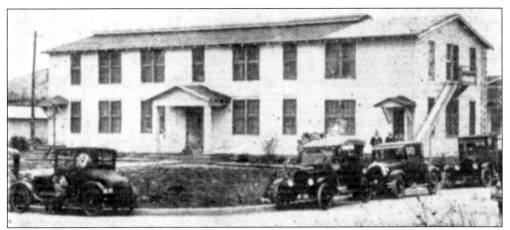

In 1922, the district bishop of the Methodist Episcopal Church, South, appointed Rev. E. H. Lightfoot to start a church in Arlington Heights. He borrowed $100 to buy a Camp Bowie hospital building for conversion to a house of worship; members called it "the shack." By 1928, the congregation decided to build by units, starting with education. Their Tudor Revival structure housed a temporary sanctuary and classrooms. (Courtesy of Arlington Heights United Methodist Church.)

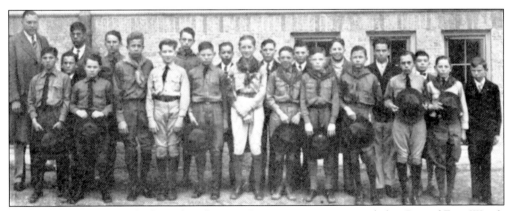

Arlington Heights Methodist Church's Boy Scout troop represented the City of Fort Worth at the 1929 regional Scout convention. Led by Scoutmaster H. C. Hildebrandt, members had their own room on the first floor of the new building. In the early 1950s, G. T. Leonard chaired a committee that completed the dream of a sanctuary in 1952. (Courtesy of Arlington Heights United Methodist Church.)

Members of the church originally named Arlington Heights Baptist Church gathered along Bryce Avenue in the rain for the ground-breaking of their basement in 1927. The resulting brick-clad, partly subterranean structure served until second and third stories could be added. In appreciation of a benefactor, the church was later rededicated as G. H. Connell Baptist Church. (Courtesy of Connell Baptist Church.)

Trinity Park Baptist Church became Soldiers' Memorial Baptist Church in the early 1920s, and then changed to Arlington Heights Baptist Church after the renaming of Connell Baptist. For a long time, members met in a former army building. A mission-style structure was completed in the 1930s. (Courtesy of Roy Lee and Ellen Brown.)

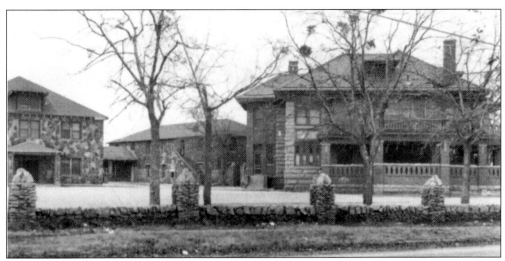

A children's residence founded by Lena Holston Pope and fellow members of Broadway Baptist Church's Martha Class, the Lena Pope Home moved in 1932 to the old Baldridge mansion (far right). She proposed paying $1 down and $150 a month, but philanthropist Leo Potishman helped her make a viable offer. Boys of the home dug dormitory foundations, and Lena drove unemployed men in her Packard from the Union Gospel Mission to a site where they broke rocks for the walls. (Courtesy of the Lena Pope Home.)

In a scene considered by staff members to be a scrapbook classic, Lena greeted some of her charges at the home's Camp Bowie Boulevard gate. She often told that her own first child, while dying, had dreamt of a mansion filled with children. (Courtesy of the Lena Pope Home.)

After Robert Flournoy died in 1924, his wife sold the Messer house. All but two children died young; Robert Jr. completed studies at the University of the South, earned a law degree, married, and moved to Wichita Falls; Martha, the youngest, made her debut. Mother and daughter left Texas for California, where they encountered members of the Hollywood set. (Courtesy of Irene McKinley Martinez.)

A branch of the extended McKinley family of McKinley Iron Works purchased the Messer house in 1925. Dining together (clockwise from left) were Edgar Snelson, Margibeth Rucker, Herman McKinley, Alois Bachman McKinley (Herman's wife), and Cora Head McKinley. Marianna Rucker Foringer recalled that she and Margibeth sold homemade sweets at a stand by the Lake Como streetcar stop. Living there, she said, "was the joy of my childhood." (Courtesy of the McKinley family.)

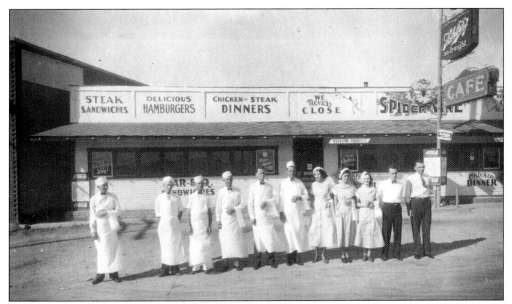

The F. D. Alexanders owned the Spider Vine Garden Café at Camp Bowie Boulevard and Hulen Street in the 1920s, followed by the Buehrig-Gudats in the mid-1930s. On duty, pictured from left to right, were Ervin Witt, Elmer McCaslin, Bill Snow, Kirby Duke, Ed Randolph, Price, Louise Quinn, Kate Dawn (the future Mrs. Dennis Gudat), Irene Slate, Dennis Gudat, and Edmund F. "Dutch" Buehrig. It was open 24 hours, offering seven brands of beer. (Courtesy of James Buehrig.)

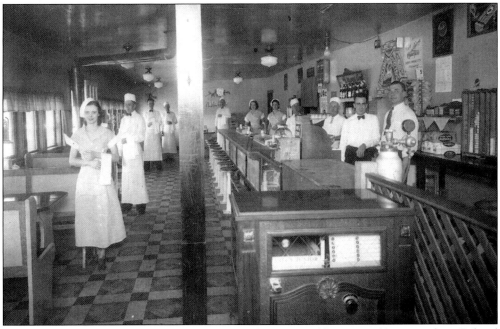

Edmund Buehrig (right foreground) had managed a Pig Stand but wanted his own place. Behind him inside the Spider Vine stood his brother-in-law and partner, Dennis J. Gudat, and Elmo, a cook. Edmund's wife, Adeline Sophia Buehrig, also worked there. Regular customers included a well-dressed man who laced his Coca-Cola with whiskey from a flask. Asked if he helped out, James Buehrig mused, "I think I ate a lot of pecan pie and ice cream." (Courtesy of James Buehrig.)

Hamlet Brosius "Bro" D'Arcy, youngest child of James and Frances D'Arcy, greeted a camera from his doorstep on Bryce Avenue. Soon afterwards, the D'Arcys moved, as did several well-to-do Heights families, to rural Benbrook. Servants accompanied them; Ollie Printer even moved with the family to New York, where James was interested in the fashionable Tuxedo Park development. (Courtesy of Bro and Dede D'Arcy.)

Born in Brimley, a lumberjack town on Michigan's Upper Peninsula, James Andrew D'Arcy met and married Frances Brosius of Indiana in 1919, taking her south to join the boom. He started a lumberyard, organized a train excursion to a Warren G. Harding rally, directed the Clover Land Company, and presided over the Texas Association of Real Estate Boards. Frances played Lady Chiltern in a 1927 staging of Oscar Wilde's *An Ideal Husband*. A *Fort Worth Press* writer announced, "A new face will go into the [Fort Worth] Little Theater's gallery of charmers." (Courtesy of National Association of Realtors.)

Jim D'Arcy found his fishing spot on Mary's Creek, near a dam his father built on their "Bois D'Arcy" property. Second Lieutenant James A. D'Arcy Jr., 36th Armored Infantry Division, Third Armored Division, was killed in his tank on August 5, 1944; his remains were buried in the Brittany American Cemetery in St. James, France, and he was posthumously awarded a Purple Heart. (Courtesy of Bro and Dede D'Arcy.)

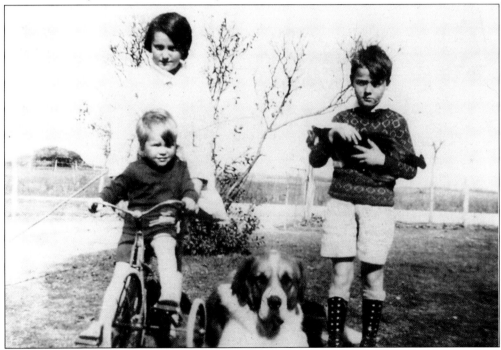

Suzanne, Bro, and Jim D'Arcy took to the outdoors in Benbrook. Suzi recalled her mother's wearying of moves to Arlington Heights houses, saying she would not take her oriental rugs to one more place. Suzi attended Arlington Heights Elementary School and before that a private Rivercrest school. Her father, she said, always carried rolled-up house plans under his arms, and his office was filled with cigar smoke. (Courtesy of Bro and Dede D'Arcy.)

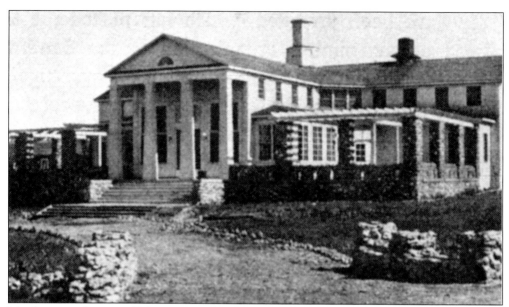

Meadowmere Country Club represented a dramatic transformation of army facilities. In 1920–1921, owners attracted crowds to the former Camp Bowie recreation area with a regional tennis tournament. The club also hosted YMCA youth swimming meets, organized moonlight horseback riding classes, and booked bands, including Milton Brown and his Musical Brownies and Jimmy's Sole Killers. Manager T. E. D. Hackney was an All-American football quarterback and war veteran. (Courtesy of Tarrant County Archives.)

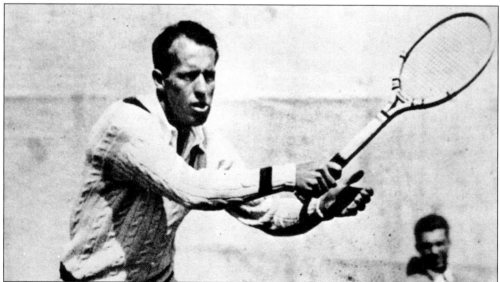

Son of the Arlington Heights Sanitarium's medical director, Wilmer Lawson Allison Jr. distinguished himself on the tennis courts of Meadowmere and far afield, at Wimbledon in 1929 and 1935, and at other major tournaments in the United States and Canada. He was inducted into the International Tennis Hall of Fame in 1963. Allison credited Hackney for welcoming him to the club even though he was not a member. Sports writer Flem Hall included Allison, Hackney, and Meadowmere in his 1968 book *Sports Champions of Fort Worth, Texas, 1868–1968*. (Courtesy of Tarrant County Archives.)

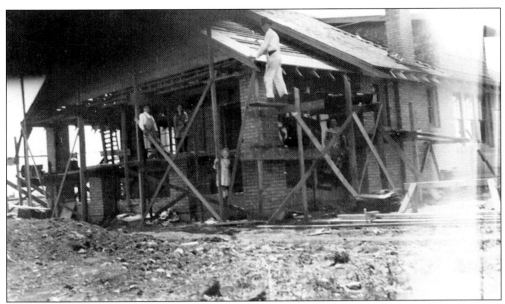

Members of the Leonard family (left to right), Perry, Mabel, Mollie, Green Thomas (called G. T.), and Mabel Emma, had a working knowledge of their house at 1900 Hillcrest Avenue. Downtown grocer G. T. was a brother of the department store partners Marvin and O. B. Leonard. (Courtesy of Sue Wells Brasher.)

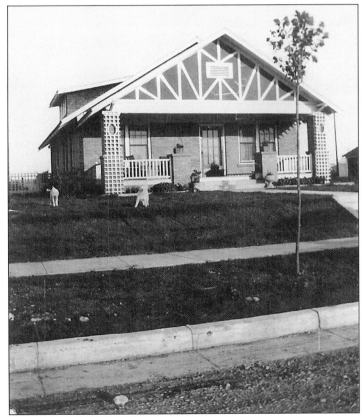

Neighborhood dogs tred on the gently sloping front lawn of the Leonards' just-completed home. (Courtesy of Sue Wells Brasher.)

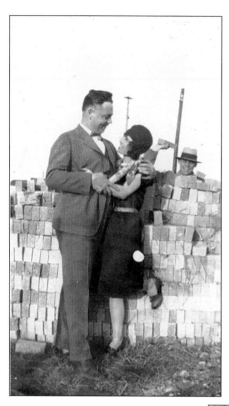

Pearl Webb Slaughter and Wyatt W. Slaughter commemorated the bricking of their house. The couple had met through a romantic radio promotion, married, traveled, and bought lots on Dorothy Lane in Tipton Place. When radio was the ultimate home entertainment medium, Wyatt Slaughter owned the local Crosley Radio franchise at The Shield Company, a furniture and appliance store downtown. (Courtesy of Wyatt and Sheila Webb.)

Completion of the Slaughters' English cottage, with many custom features, gave its owners cause for celebration in 1929. Design and construction have been attributed to Meredith Carb. A full basement, solarium, recessed shelving, decorative trim, and hideaway storage areas were among distinctive extras. The Shield Company outfitted the couple's home and, later, their apartment and hotel properties. (Courtesy of Wyatt and Sheila Webb.)

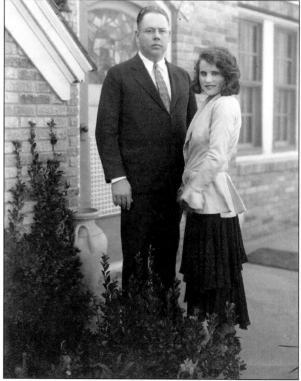

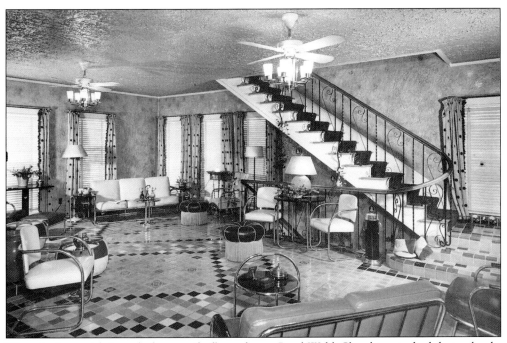

The solarium, with its polychrome tile floor, shone. Pearl Webb Slaughter studied design books and sketched out her ideas for some of the later projects and watercolored them; she may have drafted others for the main house. (Courtesy of Ann and Peter Stahl.)

Maude West Thompson, editor of *Hotel and Apartment Journal of the Southwest,* dedicated the cover of the November-December 1937 issue to the Slaughters' 49-unit complex, then called the Dorothy Lane Courts. "Mrs. Slaughter has been her own manager, landscape artist, and interior decorator. There are no cheap furnishings at the Dorothy Lane—all solid woods, velours, and tapestries." For a time during the Slaughters' heyday, peacocks ruled the enclosed garden. (Courtesy of Ann and Peter Stahl.)

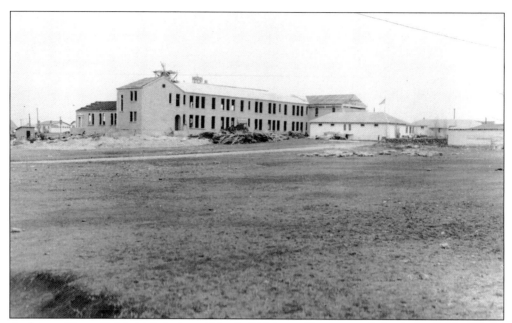

Architect Wyatt C. Hedrick designed North Hi-Mount Elementary School; the Public Works Administration provided construction laborers; and the Civil Works Administration landscaped its campus. Architect John Roberts has noted, "North Hi-Mount is one of the few schools in the Fort Worth district with its original windows still in place." A principal fought for the windows. (Courtesy of the Billy W. Sills Center for Archives, Fort Worth Independent School District.)

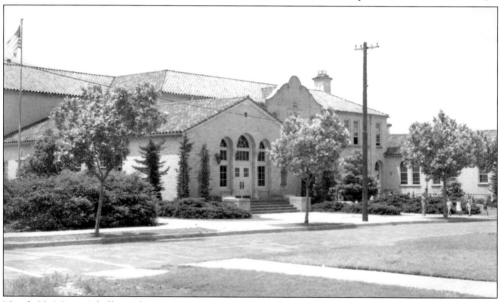

North Hi-Mount's hilltop placement on West Seventh Street enhanced the parapets of its Spanish and Mediterranean Revival lines. For many years, a tree-shaded bicycle path ran between the tennis courts and playing field and private properties. Several instructors lived at the Dorothy Lane Apartments behind the school, and one of William Walker's teachers had been a Billy Rose dancer during the Texas Centennial extravaganza. (Courtesy of the Billy W. Sills Center for Archives, Fort Worth Independent School District.)

Eva Sarsgard and son William rolled out his new bicycle into their Tremont Avenue backyard. Fort Worth's Sinclair Refinery brought the Sarsgards from Chicago, where Pierre Sarsgard's Danish father had done hazardous police duty. Pierre and Eva's only child became an attorney and civic leader; in 1967, he and other Good Government League candidates (Dr. Edward W. Guinn, Frank Dunham, Watt Kemble, Vaughn Wilson, and Ira Kersnick) swept into office; Sarsgard became mayor pro tempore. (Courtesy of Joanne Sarsgard.)

The Pershing Building, Southwestern Bell Telephone Exchange, was constructed as a one-story building in 1930. By introducing Moderne style into a bungalow neighborhood, Bell projected a forward-moving, progressive image. Judith Singer Cohen tells its story in her book, *Cowtown Moderne: Art Deco Architecture in Fort Worth, Texas*. Although its form and features have been altered twice, it retains many original terra cotta features. (Photograph by the author.)

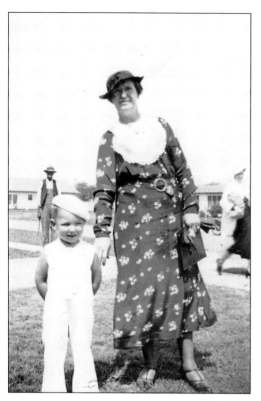

Brice Evans accompanied his grandmother, Wilhelmina (Minnie) Lebeda Brice, along Pershing Avenue. In her youth, Minnie was twice crowned queen of the Sons of Hermann-sponsored Mai-Fest. Her father was among Maximilian's Austrian bodyguards in Mexico and was a proprietor of the Bank Hotel in Fort Worth. Evans, a gifted dancer, studied at TCU and danced in New York. He established studios in Dallas and Fort Worth; generations of West Side students attended his cotillion classes. Later he developed a second career as an events planner and designer, embracing the title *festivist*. (Courtesy of Brice Evans.)

Alois Bachman (right) and her friend Eleanor Bryan dance on the front porch of the Bryan family's bungalow on Western Avenue around 1927. Alois lived at the corner of Pershing and Hulen. Both attended Arlington Heights High School. Alois married Herman McKinley, a member of the third family to own the Messer house. (Courtesy of Irene McKinley Martinez.)

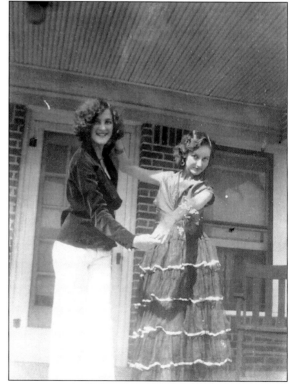

Willie Cannon, second from left in front, gathered with fellow members of her club at their Lake Como clubhouse for this c. 1940 photograph. Her son, Charles Cannon, worked for a white family in Benbrook, caddied at Ridglea Country Club, and left for California in 1944. In tribute to his home community, he created an elegiac, illustrated weblog titled *Warm Prairie Wind* in 2009. (Courtesy of Charles Cannon.)

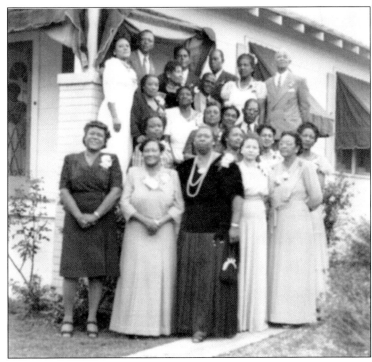

Reuben Willburn (left) and Pancho stacked cordwood in Lake Como. Charles Cannon worked for the Willburns occasionally. He wrote about the night they invited him to dinner, when he "learned that all whites were not hateful." Reuben also sold produce to African Americans in Lake Como. "If it hadn't been for the black people," his daughter said, "we wouldn't have survived the Depression." Whenever he turned down one unpaved Como Street, "a little girl would run ahead, calling, 'Here comes your peachy man!' " (Courtesy of Francis Willburn Mahaffey.)

John Graves, author of *Goodbye to a River, Hard Scrabble, From a Limestone Edge,* and other works, drew early praise from peers in the 1938 *Yellow Jacket.* He recalled the neighborhood: "It was a good place to be, where upper-middle-classers like my family mingled with wealthier folks dwelling near Rivercrest Country Club, whose progeny were only rarely sent to northeastern private schools during the Depression, which deviled just about all parents until and into WW II. Until my final year in public school I was within walking distance of my classes, first at the original Hi-Mount Elementary School, then at Stripling High, and in my final year before college at the brand-new Arlington Heights High, farther away to our southwest. And we boys had easy access to hunting and fishing in undeveloped country along the shores of the Trinity River's West Fork, where we were of course trespassing but it didn't seem to matter." Among Rivercrest friends, he counted Olcott and David Phillips. From left to right in the c. 1923 photograph below are Edwin Jr., James, Olcott, and David Phillips, with Wolf. (Above, courtesy of Dalton Hoffman; below, courtesy of Beth Phillips Engelhardt.)

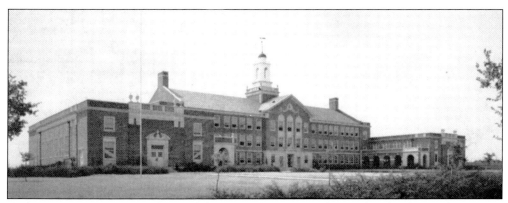

Architect Preston M. Geren designed the new Arlington Heights High School, a Works Progress Administration project. The Georgian Revival structure opened in the fall of 1937. If its double-hung, wood sash windows were restored, it would be eligible for listing with the National Register of Historic Places, according to authors of the 1988 historic resources survey. (Courtesy of the Billy W. Sills Center for Archives, Fort Worth Independent School District.)

Students accustomed themselves to the spacious lobby of their new high school. The 1938 *Yellow Jacket* featured several exterior and interior views of the building. (Courtesy of the Billy W. Sills Center for Archives, Fort Worth Independent School District.)

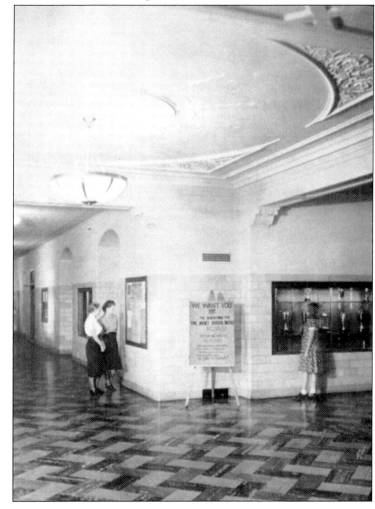

The children of Dr. Leo E. Phillips and Ulva Clair Phillips (left to right), Robert, Thomas, William, and Leo Jr. gathered outside their Bryce Avenue home in 1940. All served in the military. Staff Sgt. Leo Entler Phillips Jr., U.S. Army Air Forces, flew with the 499th Bomber Squadron. His airplane disappeared over the Pacific August 12, 1945; posthumous honors included an Air Medal with two oak leaf clusters and a Purple Heart. (Courtesy of Margie and Tommy Phillips.)

Frances Knepfly McCart welcomed a photojournalist into her parlor for a 1941 assignment that resulted in a full-page *Fort Worth Star-Telegram* feature about the history of the family and the house. (Courtesy of the *Fort Worth Star-Telegram* Collection, the University of Texas at Arlington.)

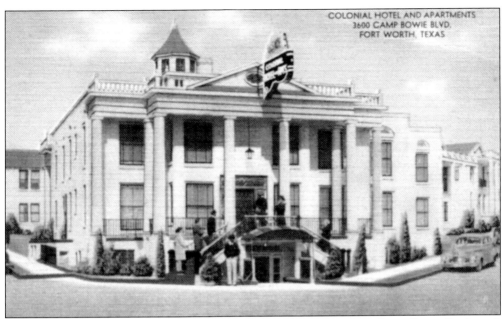

In 1940, Pearl Slaughter opened the Colonial Hotel and Apartments at Camp Bowie Boulevard, Montgomery Street, and Bertrose Avenue. An admirer of American colonial architecture, she incorporated favorite features into the Colonial, the Homestead Home (an unwed mothers' facility overlooking West Vickery), and a country home. For a while, she installed some expectant mothers in the hotel. (Author's collection.)

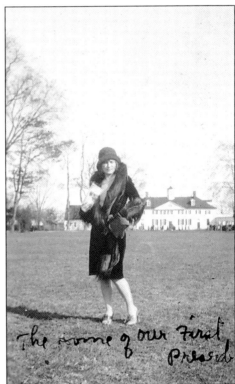

Pearl and Wyatt Slaughter had visited Mount Vernon in 1929, either because of her love for all things colonial or on a tour that inspired her affinity. (Courtesy of Wyatt and Sheila Webb.)

Deliverymen for Renfro's Drug revved up their motorcycles beside the Zeloski home a few years before its demolition, which made way for the Bowie Theater at the intersection of Camp Bowie Boulevard and Zeloski Street. (Courtesy of Ben J. Eastman Jr.)

Interstate Theatres introduced the Bowie Theater in 1940, on the land where the Zeloski family had lived. During the war years, manager Dan Gould initiated a program for neighborhood children to redeem scrap metal and grease for admission to a Saturday matinee. (Courtesy of the Fort Worth Chamber of Commerce and the Genealogy, History and Archives Unit, Fort Worth Public Library.)

Six

ON THE SECOND WAR'S HOME FRONT

WATCHING THE SKIES

1941–1945

Our club we called the Kid Korps—Frank Burkett was the general. I really looked up to him and still do, though many miles apart for many years. I was thrilled when I was admitted to the Korps as a buck private (Frank was seven years older than I) and later was promoted to corporal. I don't think I got any higher. We had a clubhouse in the Burketts' backyard. We had a decoding key—I think we got it from Ovaltine, the sponsor of Captain Midnight—and photos of German and Japanese warplanes, so we could spot them if they flew over Arlington Heights. The block then had a number of vacant lots; we dug caves and had secret places in almost every one of them. The Korps consisted of both boys and girls. Although the early 1940s was a time of a terrible war, my memories of the years on Tremont then are happy ones.

—John Robertson
Emeritus Professor of Religious Studies
McMaster University, Hamilton, Ontario

Mobilization for war wrought great change to Arlington Heights, but in a less visible way than when the thousands of doughboys had disembarked from trains for a sojourn at Camp Bowie. The most obvious indicators of change were the still-empty residential and commercial lots.

Uniformed loved ones posed for farewell snapshots on front steps and sidewalks, knowing they might not stand there again. Children scrounged for scrap metal. Stars appeared in house and apartment windows. Newcomers and their families sought housing relatively close to Fort Worth's major new employer: the Consolidated Vultee aircraft plant at Lake Worth.

At Arlington Heights High School, the Reserve Officers' Training Corps grew in ranks. A student cartoonist militarized the mascot, sketching a single-file takeoff of fighting yellowjackets for the yearbook cover.

Distant from the unspeakable torture and slaughter of the Holocaust, treacherous oceans, and multiple battlefronts, children from different faiths and backgrounds played together in yards and on porches, forming lifelong bonds of friendship.

Berniece Smulion Weil led her son Leon ("Bootsey") and daughter Lynny from the car at their home on Thomas Place. Later they lived on Tremont Avenue. Her husband, Marion Weil, was chief haberdasher for Washer Brothers. Throughout their years in Fort Worth, the Weils were active in many civic and Jewish causes. (Courtesy of Lynny Weil Sankary.)

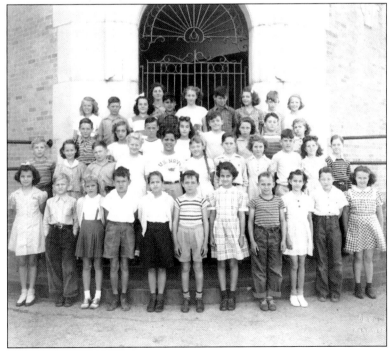

No 255|192 AC UNITED STATES OF AMERICA
OFFICE OF PRICE ADMINISTRATION

WAR RATION BOOK TWO
IDENTIFICATION

Sharon Symm Weil
(Name of person to whom book is issued)

1715 Thomas Pl
(Street number or rural route)

Ft. Worth _Tex_ _2_ _female_
(City or post office) (State) (Age) (Sex)

ISSUED BY LOCAL BOARD No. _Tex 220 Tarrant_ _Tex._
(County) (State)

5'00 Main _Ft Worth_
(Street address of local board) (City)

By _Price Moore_
(Signature of issuing officer)

SIGNATURE _Mrs M ___ W Weil_
(To be signed by the person to whom this book is issued. If such person is unable to sign because of age or incapacity, another may sign in his behalf.)

OFFICE
OF
PRICE ADM.

R-123
255192 AC

WARNING

1 This book is the property of the United States Government. It is unlawful to sell or give it to any other person or to use it or permit anyone else to use it, except to obtain rationed goods for the person to whom it was issued.

2 This book must be returned to the War Price and Rationing Board which issued it, if the person to whom it was issued is inducted into the armed services of the United States, or leaves the country for more than 30 days, or dies. The address of the Board appears above.

3 A person who finds a lost War Ration Book must return it to the War Price and Rationing Board which issued it.

4 PERSONS WHO VIOLATE RATIONING REGULATIONS ARE SUBJECT TO $10,000 FINE OR IMPRISONMENT, OR BOTH.

OPA Form No. R-121

16—30853-1

Lynny's mother placed her last ration book cover, with no stamps left unused, into her baby book for future generations to see. (Courtesy of Lynny Weil Sankary.)

Members of a third-grade class posed before the ornamental gates at one of the side entrances to North Hi-Mount Elementary School in 1943. Patricia Collins, who grew up in the home D. O. and Maud Modlin had first owned, stood seventh from left on the front row. (Courtesy of Patricia Collins Massad.)

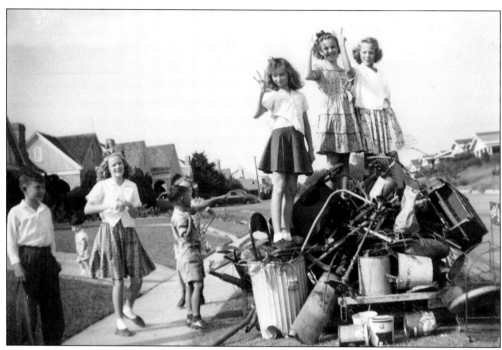

The Kid Korps of Tremont Avenue hunted down mountains of scrap metal for victory. Volunteers (left to right) included Gene Witkowski, Arthur Robertson, Kay Guinn, John Robertson, unidentified, Dorothy Paddock, Sally Walker, and Jane Burkett. (Courtesy of Dorothy Paddock Dickson.)

The Shooting Star—written, lettered, illustrated, and hand-duplicated on a cookie sheet with hectograph gelatin by Burkett brothers Frank and Jim and friend Phil Stout—covered war news as well as the home front. They sold advertising up and down Camp Bowie Boulevard, designing and illustrating display ads. Sallie Burkett bundled up her sons' surplus copies in a used Texas Highway Department envelope and put them away for safekeeping; Frank rediscovered them in 2008. (Courtesy of Frank Burkett.)

Betty Marie Moore Griffey and son Adrian called Ashland Avenue home. She purchased their house with earnings from her North Side beauty salon. Several years earlier, she had picked extra cotton on the family farm in Palo Pinto County to fund her transportation to Fort Worth and beauty college tuition. William H. Griffey, her husband, was overseas with Patton's Third Army. (Courtesy of Karen Griffey.)

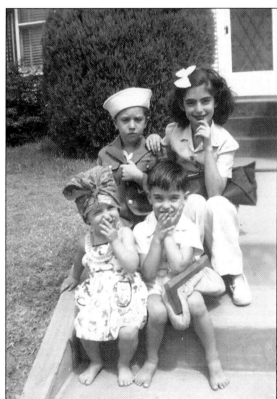

Lynny and her brother Bootsey Weil (in sailor hat) and cousins Hilda Lou and Jack Cohen helped celebrate Lynny's first home permanent in 1943. (Courtesy of Lynny Weil Sankary.)

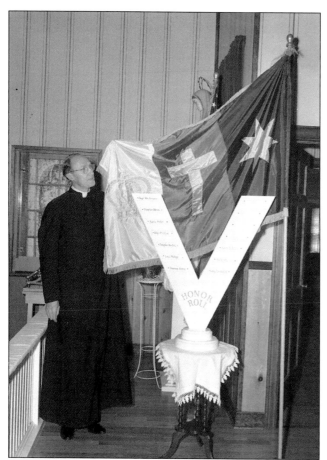

Fr. Ernst G. Langenhorst, founding pastor of St. Alice's Catholic Church, held a banner-listing parishioners serving in World War II. The priest, a refugee from the Netherlands, celebrated the first mass in the modest sanctuary in 1942, sharing his concept of a "living parish" greater than its land and buildings. James Buehrig, long a part of St. Alice's, wrote that "Father Langenhorst and St. Alice's, they are one." An online memorial to those who "were passionate about the reform of Roman Catholic Liturgy," *Liturgical Pioneers: Pastoral Musicians and Liturgists* includes the priest, who died in 1983. St. Alice's church and school closed after 23 years when the Holy Family parish was established in Ridglea. (Courtesy of the *Fort Worth Star-Telegram* Collection, Special Collections, the University of Texas at Arlington.)

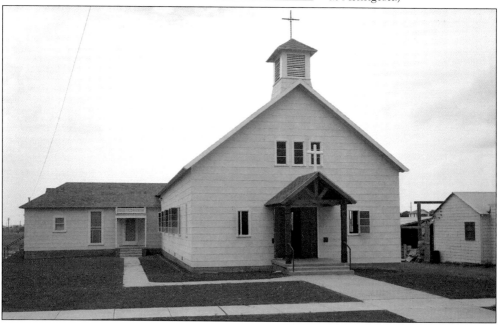

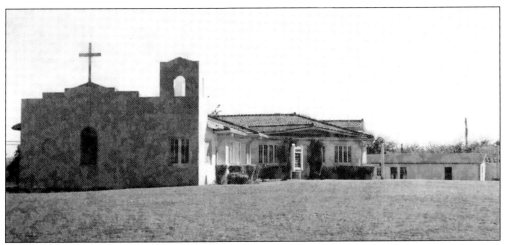

Trinity Lutheran Church began in the World War II era as Consolidated Vultee drew talent from Bosque County's Norwegian American communities. Members worshipped in the Public Market, with a makeshift pulpit of cardboard cartons. Beno Grimland and his son, Irvin, converted a former Harveson and Cole Funeral Home branch at Camp Bowie, Montgomery, and Tulsa Way into a church, adding a parsonage wing. The Reverend Erling Wold was first pastor; his wife, Margaret Barth Wold, helped bring about ordination of women pastors in the American Lutheran Church. Later clergy included the Reverend Dr. John Tietjen, former president of a Missouri Synod seminary, who created a breakaway school in the early 1970s and worked to unite two Lutheran branches. Margie Bertelsen grew up in Cranfills Gap, Bosque County, and volunteered for Red Cross work at the end of the war. Several members of the Grimland and Bertelsen families were among the charter members of Trinity. (Courtesy of Margie Bertelsen Rhoades.)

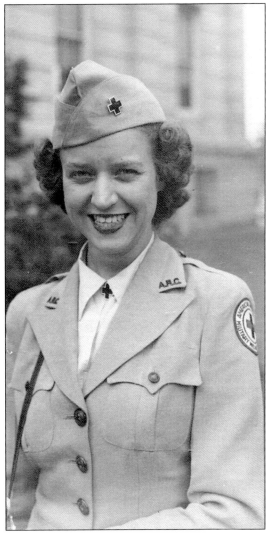

Second Lt. George B. Neely, his wife, Alois, and their daughter, Becky, prepared to say farewells outside his parents' home on Bryce Avenue, across from the Roscoe Minton home. George flew a B-17, which was shot down in Europe; he survived his time in a German POW camp. (Courtesy of George Neely.)

Six seaworthy Arlington Heights High School alumni took a break in "The Little Club," a coffee shop in San Diego's U.S. Grant Hotel, before shipping out into the Pacific theater of war: (left to right) Jimmy O'Hara, Earl Chester, Jerry Nail, Bill Snow, Paul "Swifty" Tillery, and, as penciled in on the back of the photograph, "Dud Curry tryin to frown." (Courtesy of Lou Snow.)

Seven

POSTWAR METAMORPHOSES

GAINS AND LOSSES

1945–2010

Whenever I go back, I am now fairly impressed how solid, square and relatively stable the old neighborhood is. It has aged well. . . . I like to think a little article I did for Texas Monthly *back in the 1970s about Camp Bowie Boulevard about to be asphalted over had something to do with preserving the brick surface.*

—Joe Nick Patoski
author of *Willie Nelson: An Epic Life, Selena: Como La Flor,
Big Bend, Texas Mountains*, and other works

The story was universal, playing out everywhere. After victory celebrations came renewed and new courtships, weddings, reunions, and resettlements.

Then the fast-forwarding began. Baby boomers came along and, when they could walk, shadowed older children and teenagers who remembered the war years. Outdoor social life continued for a while, with front porches, lawns, parks, and school fields the familiar venues. Amon G. Carter donated Lake Como and the surrounding land to the city as a park for African Americans. Ravines and vacant stretches disappeared. Infill bore little resemblance to prewar period designs. Air conditioning and television trumped heat and radio. Neighbors withdrew into cooler interiors and marveled at cathode-ray tubes. Neighborhood cinemas lost revenue. Burgeoning hospital, medical school, and church campuses claimed many dwellings. A cultural district grew up just across the road.

The assassination of John Fitzgerald Kennedy truly hit close to home. Some Arlington Heights residents had gone downtown on the morning of November 22, 1963 to see the President and First Lady outside the Hotel Texas. Mother of Lee Harvey Oswald, Marguerite Oswald lived across the street from Stripling Junior High School.

Independent businesses coped with the growth of chains and franchises. Young, upwardly mobile professionals grew interested in acquiring and dramatically altering older homes. Preservationists awoke to the sight of teardowns and then to incompatible structures put up in place of bungalows and cottages. Arlington Heights Neighborhood Association; Historic Camp Bowie, Inc.; and Historic Hillcrest, the first historic district, formed. Defenders of Camp Bowie Boulevard's brick pavement made strong arguments against calls for a smoother ride and cheaper maintenance. The bricks prevailed in beautiful Arlington Heights.

Kathy Lamb viewed the world of Western Avenue. (Photograph by Peggy Miller Lamb and courtesy of Nancy Lamb.)

Birthday king John Lamb presided over his cake at a backyard party. (Photograph by Peggy Miller Lamb and courtesy of Nancy Lamb.)

With David Heath and other neighbors, John Lamb (in front) dressed up and paused for a c. 1949 photograph on his front porch on Western in the Hill Crest Addition. A few years later, the baby of the family, artist Nancy Lamb, was born. (Photograph by Peggy Miller Lamb and courtesy of Nancy Lamb.)

Alice Roberta McCart McAllister tossed her bouquet down the stairway of the McCart mansion. She had grown up in and near the home of her grandparents, and among her childhood haunts were the pond, the carriage house, and what she was told were the last vestiges of Ye Arlington Inn. (Courtesy of Alice Roberta McCart Walters and Roberta E. McAllister.)

Newlyweds Mr. and Mrs. Thomas G. McAllister descended the stairs of the McCart home. (Courtesy of Alice Roberta McCart Walters and Roberta E. McAllister.)

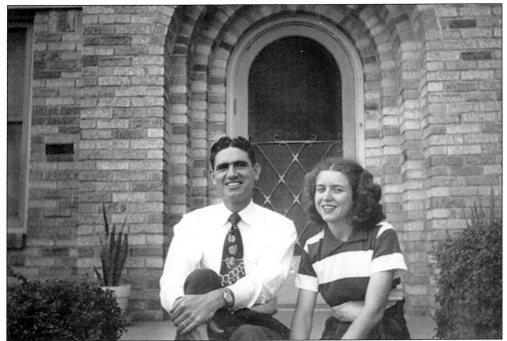

After serving in both the U.S. Navy and U.S. Marine Corps and participating in the second assault wave on Okinawa and the occupation of Tsien-tsen, China, pharmacist Charles Rhoades resumed his courtship of Margie Bertelsen. She had returned in 1948 from a three-year Red Cross assignment in Germany and Austria and was teaching and living at the Frederick Street home of her mother, Alice Tergerson Bertelsen. They married in 1949. (Courtesy of Margie Bertelsen Rhoades.)

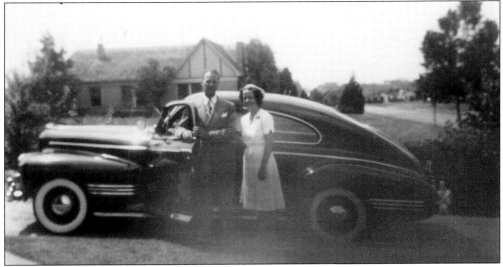

Neighborhood newlyweds included Martha Faulkner Smith and Marcus Smith. She chaired the home economics department at Texas Wesleyan College; he had returned from the film-cutting rooms of Hollywood—having decided, after working on *Gone with the Wind*—to pursue a different career. During the war, Martha had directed the home canning education program for Tarrant County. (Courtesy of Marcus Smith Jr.)

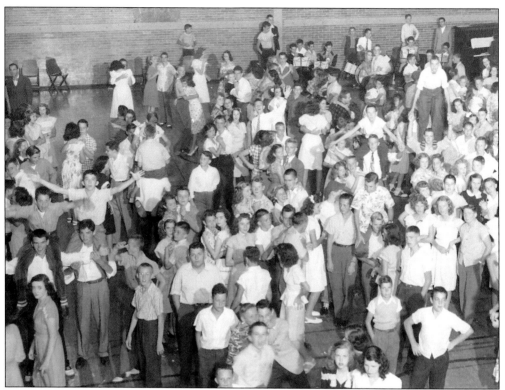

At a W. C. Stripling Junior High School teen canteen of 1945, gravity did not keep happy feet on the gymnasium floor for long. (Courtesy of David Pearson.)

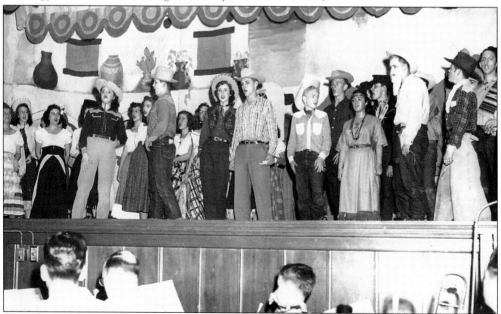

Meet Arizona, the musical performed at Arlington Heights High School in 1949, featured future Metropolitan Opera star William Walker at right, in a plaid shirt. (Courtesy of the late William Walker.)

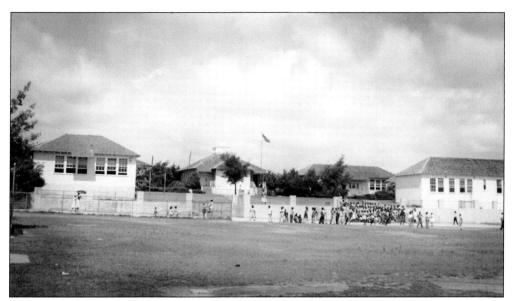

In 1946, the Lake Como school complex still served younger students in what may have been a grouping of adapted Camp Bowie buildings from World War I. Until the mid-1950s, African American high school students had to commute to I. M. Terrell High School east of downtown. (Courtesy of the Billy W. Sills Center for Archives, Fort Worth Independent School District.)

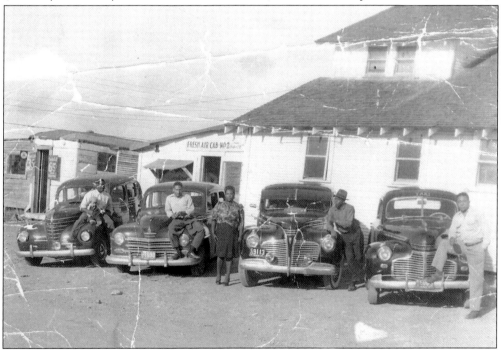

Fresh Air Cab personnel waited near Vance and Vi Grant's Blue Bird Café, a converted streetcar. Charles Cannon remembered: "Originally a food-only café with a jukebox, it gained in popularity despite a lack of room for dancing." In the Zoot-Suit era, "the pre-eminent figure in the neighborhood was Marshall 'Bull Dawson' Dixon . . . when Bull Dawson went up to the Blue Bird . . . he was untouchable . . . everybody jitter-bugged then, and he was tops." (Courtesy of Sumter Bruton.)

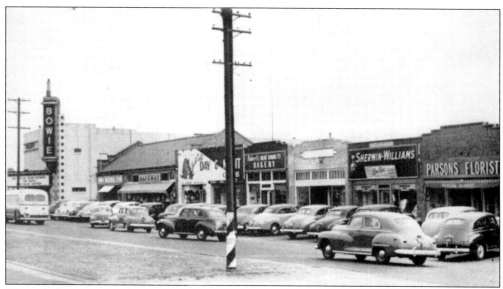

The Zeloski commercial rows built by Harry Friedman, continuously occupied since the 1920s, still constituted a prime location in 1949. Its storefronts have hosted a bowling supplier; the original Green Front variety store; E. B. Mott 5¢, 10¢, and 25¢; Miller and Hanger Grocery; The Blind Pig; Vogue Cleaners; Sunflower Shoppe; Blue Bonnet Bakery; Vernon's Beauty Salon; and more. The 1949 *Yellow Jacket* included this scene in its city centennial tribute. (Courtesy of Michael McDermott.)

Clover Farm Stores, which was a partnership of grocers Roy Pope and Charles Kincaid, began in the late 1940s. Clover, a kind of a cooperative with its headquarters in Ohio, emphasized self-service and sleek refrigerated sections. Pope decided to return to his original store on Merrick, and Kincaid stayed in the new building, eventually going independent and renaming it. (Courtesy of the Fort Worth Chamber of Commerce and the Genealogy, History and Archives Unit, Fort Worth Public Library.)

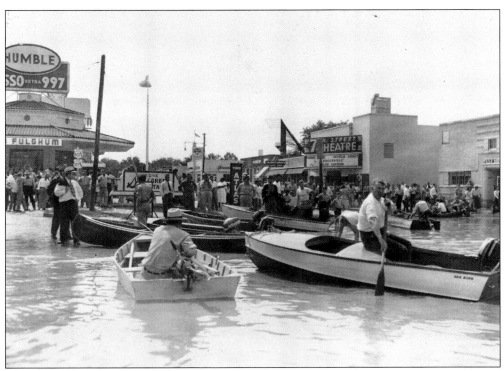

The great flood of 1949 brought out a fleet of rescue boats; volunteers converged at the intersection of Camp Bowie, West Seventh Street, University Drive, and Bailey Avenue. Even at a higher elevation in Rose Hill, the sloping backyard of the Ashworth Apartments on Mattison Avenue filled with water. This displaced a few snakes and tarantulas that delighted adventurous brothers John S. Estill III and James C. Estill while they were visiting their grandmother there. (Courtesy the *Fort Worth Star-Telegram* Collection, Special Collections, the University of Texas at Arlington.)

Arlington Heights High School's 1948 football team brought home glory, which still inspired alumni in 2010. (Courtesy of William J. Trotter.)

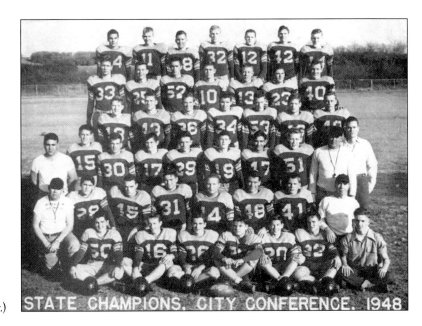

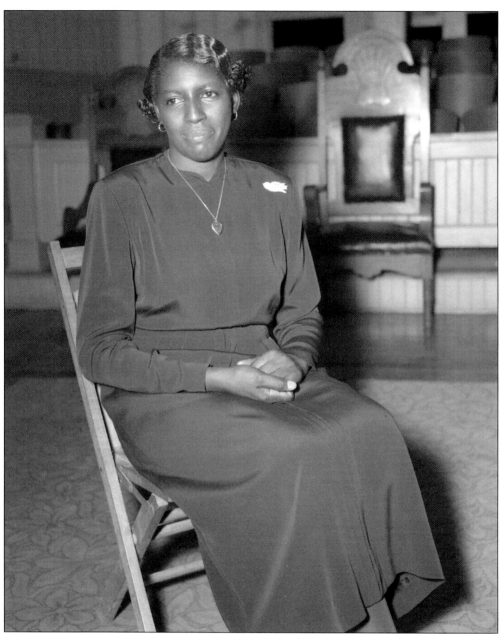

At Pleasant Mount Gilead Missionary Baptist Church, soloist Tommie Lee Jackson Jenkins, "the songbird," was one of three featured choir musicians in the late 1940s. She sang at other churches and for special events, recorded, and is still remembered for her gifts. In *Calvin Littlejohn: Portrait of a Community in Black and White,* Bob Ray Sanders wrote, "Those sanctuaries scattered throughout the black neighborhoods were not just places of worship; each was a refuge, a security zone, a solid rock in a land that sometimes seemed alien for a people who faced constant discrimination. . . . For special occasions . . . the people wanted a photographic record, and Calvin Littlejohn was there." (Courtesy of Ron Abram, the Calvin Littlejohn Estate, Arlington, Texas, and the Calvin Littlejohn Photographic Archive, Dolph Briscoe Center for American History, the University of Texas at Austin.)

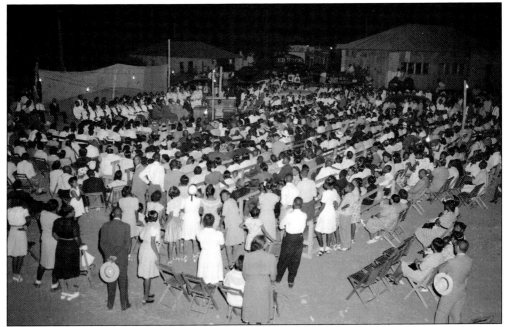

A night event associated with Pleasant Mount Gilead drew a crowd. It was not unusual for more than one congregation to collaborate on a revival service. (Courtesy of Ron Abram, the Calvin Littlejohn Estate, Arlington, Texas, and the Calvin Littlejohn Photographic Archive, Dolph Briscoe Center for American History, the University of Texas at Austin.)

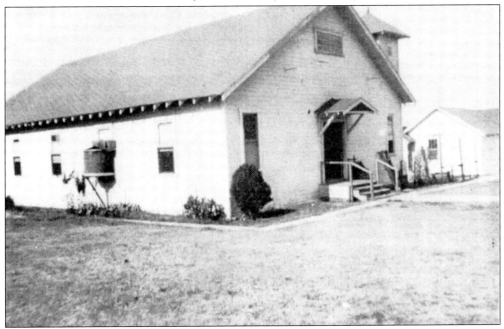

Pleasant Mount Gilead represented a merger of two Lake Como congregations in 1916: the Mount Pleasant Baptist Church and the New Mount Gilead Baptist Church. In the 1950s, members dedicated a new brick-clad sanctuary and education building that replaced the older frame structure. (Courtesy of Pleasant Mount Gilead Missionary Baptist Church.)

Blue Birds of Thomas Place Elementary School assembled on the side lawn with teacher Jessie Catherine Street. In 1954, a tiny 7-Eleven store stood along Clover Lane, just across the street from the brick triplex (partly hidden by its carport) that some say was built as a teacherage. (Courtesy of Susan Hoera Toppin.)

Bryan Teague drove the Leonard's movie wagon in the early 1950s, bringing people together to see free films outdoors. Laid off from General Dynamics, Teague had acquired projection skills at the Haltom and New Isis Theaters. He could not get into the projectionists' union, but Leonard's Department Store hired him. Stripling student Jim Dawson caught shows at his school's field; others saw them on the South Hi-Mount Elementary campus. According to the authors of *Texas Merchant: Marvin Leonard and Fort Worth*, Leonard's had also screened free movies in parks in the 1930s. (Courtesy of Linda Teague Marr and Marty Leonard.)

The just-completed sanctuary of All Saints Episcopal Church waited briefly, unadorned, in 1954. Many carvings and stained-glass windows were added and are explained in David Lindsey's book *The Saints and Symbols of All Saints*. Parishioners created the church's original altar, currently installed in its Chapel of the Angels; before they had a permanent structure, it was used in the Westover Hills town hall in 1948, the Arlington Heights Masonic Lodge in 1949, and the parish church through 1954. (Courtesy of All Saints Episcopal Church.)

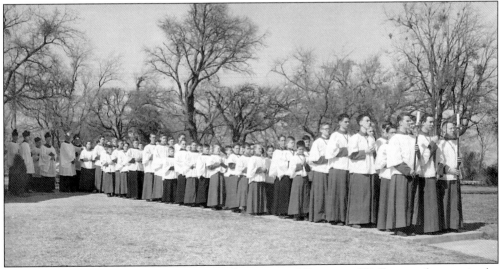

Acolytes traveled from many churches in the Episcopal Diocese of Dallas to take part in the procession to the new sanctuary on All Saints' Day, November 1, 1954. Designed by architect Herman Cox, the Gothic structure was built with Leuders limestone. (Courtesy of All Saints Episcopal Church.)

The Brutons moved to the El-San Apartments, at El Campo and Sanguinet, in the postwar era. Future virtuosi Sumter (left) and Stephen grew up with an eclectic mix of music. Their father was a jazz drummer, and Record Town was the family business. Blues historians often consult Sumter, regarded as a master of the T-Bone Walker guitar style. Stephen performed with Bob Dylan; toured with Kris Kristofferson, Bonnie Raitt, and others; and collaborated with T Bone Burnett on music for the 2009 film *Crazy Heart*, which premiered several months after his death. Burnett told arts writer Preston Jones that his longtime friend "had the greatest, most realistic, bitterly funny version of life on the road. I definitely wanted him to come in and write the songs and just be there for Jeff [Bridges] to watch. A little bit of Stephen lives on in the character." (Photograph by and courtesy of Kathleen Bruton.)

Pictured around 1956, Don Simpson and his cousin Beth Phillips found dining room doors to be handy props for clowning inside the home of their grandparents, Robert Lee Simpson and Charlotte Stewart Simpson, on Hillcrest Avenue. (Courtesy of Beth Phillips Engelhardt.)

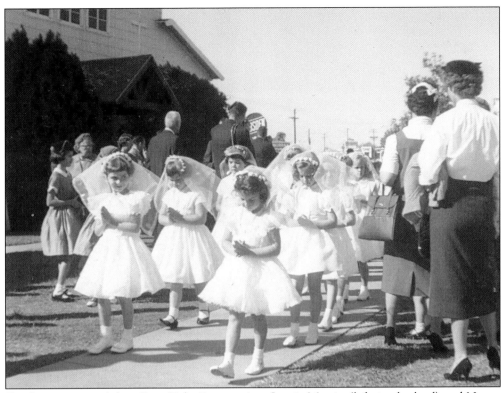

On the occasion of their First Holy Communion, Jeanie Martin (left, in the lead) and Nancy Phillips (right, in the lead) processed on May Day 1959 at St. Alice's Church. (Courtesy of Margie and Tommy Phillips.)

Alice Jane Rhoades tried out a wheelbarrow on Harley Street in Queensborough Heights, with an awning-adorned minimal traditional house behind her. Among her family's neighbors on the block was *Fort Worth Star-Telegram* entertainment columnist and humorist Elston Brooks. (Courtesy of Margie Bertelsen Rhoades.)

Como Junior-Senior High School opened on Littlepage Street in the 1950s. It began serving its first 10th-graders in 1954, the year of *Brown v. Board of Education*. (Courtesy of Ron Abram, the Calvin Littlejohn Estate, Arlington, Texas, and the Calvin Littlejohn Photographic Archive, Dolph Briscoe Center for American History, the University of Texas at Austin.)

Mothers filled the stage at a district PTA conference at Como High School. In her 1987 *Griot* journal essay, "Older Blacks as Social Historians," Joyce Williams interviewed 35 Lake Como residents and found that one common concern was that new generation did not realize what elders had gone through to make their lives better. (Courtesy of Ron Abram, the Calvin Littlejohn Estate, Arlington, Texas, and the Calvin Littlejohn Photographic Archive, Dolph Briscoe Center for American History, the University of Texas at Austin)

Como High School majorettes (above) performed at a night game in the 1950s. (Courtesy of Ron Abram, the Calvin Littlejohn Estate, Arlington, Texas, and the Calvin Littlejohn Photographic Archive, Dolph Briscoe Center for American History, the University of Texas at Austin.)

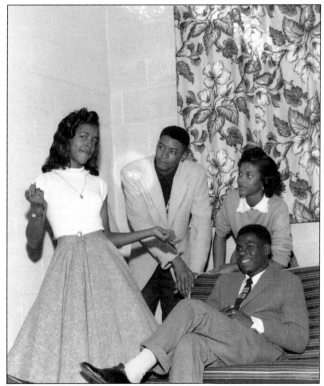

Como High School's 1957 junior class favorites were Petricious Bradley (far left) and Billy Lenear (seated at right). As alumnus Estrus Tucker told Bud Kennedy about the school's 1971 closure, it was "like being orphans." Kennedy explained, in a 1992 *Fort Worth Star-Telegram* column, how some 25 seniors "were among the 120 Como students dumped into Heights, a school of 2,400." "We lost our scholarships, our recognition, our awards," Tucker said. And, Kennedy concluded, they lost "the embracing arms of the Como neighborhood." (Courtesy of Ron Abram, the Calvin Littlejohn Estate, Arlington, Texas.)

Bill Camfield, director of Channel 11's continuity department, created a manic role model for baby boomers whose TV antennae received the station's live transmissions. As Icky Twerp, he hosted *Slam-Bang Theater*, bossing his Barefooted Foot-Runners and introducing *Three Stooges* features. He also assumed the mantle of Gorgon, an ominous night creature who introduced horror movies, and invented other characters for programs and commercials. (Courtesy of Paul Camfield.)

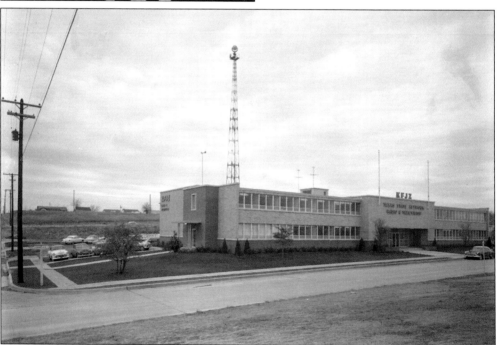

"Lively Eleven," KFJZ-TV, opened September 11, 1955, on West Rosedale. Founded by the Texas State Network, it was the first independent television station in Texas and the sister station to KFJZ Radio, which was also headquartered there. (Courtesy of the W. D. Smith Collection, Special Collections, the University of Texas at Arlington.)

Hilda Cohen hired on at Channel 11 to write commercials, and Dick Clayton joined as a projectionist. They soon became a mud turtle and a possum. "We started *Mickey and Amanda* in December 1955 (with no pay, FYI)," Hilda recalled. "By the end of 1959, we were on the air live for two and a half hours a day, six days a week. Dick and I ad-libbed all of the shows. We both loved children and were inspired by them." The Fort Worth Fat Stock Show and Exposition Rodeo was on the puppeteers' crowded public appearance schedule. (Courtesy of Hilda Cohen Jackman.)

Amanda took the wheel of the petite Corvette while Mickey enjoyed an evening's cruise in the neighborhood. Since those days, Hilda Cohen Jackman, professor emerita with the Dallas Community College System, authored *Sing Me a Story! Tell Me a Song!* and *Creative Thematic Activities for Teachers of Young Children*. Dick Clayton retired from a long broadcasting career and created a Web site filled with images and anecdotes. (Courtesy of Hilda Cohen Jackman.)

Her residence at the time of the assassination, Marguerite Oswald's house on Thomas Place was demolished and replaced with a modern structure. The image is a still derived from 1963–1964 television news footage shot for a Dan Rather interview. A Stripling teacher recalled that one of the newspapers printed the wrong address in late November 1963; residents of that house received threats and hurriedly put up a yard-sign correction. (KRLD-TV/KDFW Collection, courtesy of The Sixth Floor Museum at Dealey Plaza.)

During a 1978 interview at a different residence, Marguerite Oswald sat near her framed copy of *Whistler's Mother.* (Courtesy of the *Fort Worth Star-Telegram* Collection, Special Collections, the University of Texas at Arlington.)

Joe Nick Patoski, Arlington Heights High School class of 1969, appeared in that year's *Yellow Jacket* in his cheerleading uniform. Some 41 years later, he reflected, "It's not the same place where I grew up . . . not quite as wide open as it once was, when a kid could ride his or her bike or take the bus downtown . . . or go hang in the Rivercrest Country Club parking lot even though our family didn't 'belong,' go parking (and drinking underage) in our cars at night on Hidden Road or go clubbing in Como without fear or worry. My friends included a few Mexican American kids in Brooklyn Heights, including Henry and Johnny Molina, with whom I walked to Stripling (after walking real slow past the Capri Theater). Brooks Drug in the same shopping center was a great hangout to read comics and play pinball. I like to think one of the great things about growing up in the Arlington Heights neighborhood was the diversity . . . I had friends from Lena Pope Home and friends whose parents were multimillionaires." (Author's collection.)

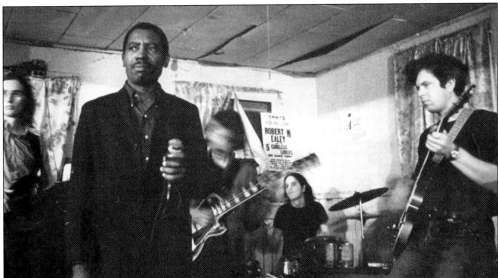

Robert Ealey and the Five Careless Lovers, (left to right) Jack Newhouse, Robert Ealey, Freddie Cisneros, Mike Buck, and Sumter Bruton, played at Ealey's New Blue Bird Nite Club, where musicians and music lovers mixed at the site of the old Blue Bird. Pianist Ralph Owens was out of camera range. Ealey hosted and influenced Jimmie and Stevie Ray Vaughan, ZZ Top, T Bone Burnett, Johnny Reno, and the Fabulous Thunderbirds. Ironically, one night in 1921, local police made a mass arrest at Lake Como's Midnight Ramblers Club, taking 117 people to jail for loud music and partying. (Photograph by Vince Foster, courtesy of Sumter Bruton.)

A member of the storied Fort Worth Circle of artists, Bror Utter lived and painted for years on Mattison Avenue, until the expansion of Texas College of Osteopathic Medicine in 1980 forced him to go elsewhere. He moved from his custom-designed house with two studios and a Japanese garden to the Parkview Apartments, where the Modern Art Museum of Fort Worth now stands. (Courtesy of Amon Carter Museum Archive, Fort Worth, Texas, Virginia Carden Collection of Bror Utter Papers.)

Susan Urshel and Paul Schmidt, who came to Fort Worth in 1983 as estate gardeners, bought a Madeline Place bungalow, planted a tangled English garden, and began hosting a weekly neighborhood potluck vegetarian dinner party. They did this so their children, Stuart and Lindsey (foreground), could enjoy family dinners like those Susan remembered from her North Carolina childhood. They continued the tradition until both sons had left for college. (Courtesy of Susan Urshel and Paul Schmidt.)

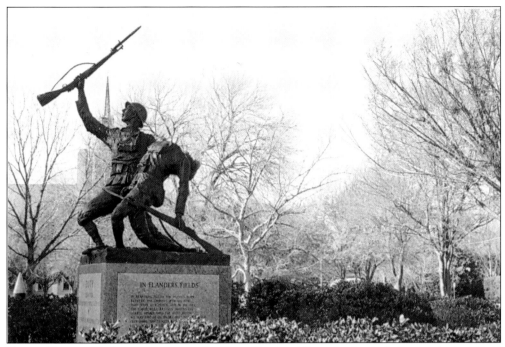

Duty in Veterans' Park commemorates the Camp Bowie soldiers who fought in France during World War I. Barvo Walker, a 1949 graduate of Arlington Heights High School, was the commissioned sculptor. The carillon tower of Arlington Heights United Methodist Church stands to the west. (Photograph by the author.)

In the 1980s, Como High School alumni commissioned an arched entrance for the African American graveyard. Charles Cannon paid tribute in his *Lake Como Cemetery Elegy*, excerpted in the following: "Most of those buried
beneath that hard earth
lie in unmarked graves.
Galvanized markers long
ago disintegrated.
The names and images of
the dead missing
from the conversations of visitors
privileged to walk here now.
All eventually will be forgotten
But while we who are alive still remember
let us sing songs of mourning love."
(Photograph by the author.)

Standing on the south patio of Arlington Heights High School, Bill Snow spoke of fallen servicemen among the alumni. Veterans worked with school officials and the military branches to create a memorial on the campus. In 2003, they unveiled a monument engraved with the names of 28 who died in service to the United States during World War II and the Korean conflict. (Courtesy of Lou Snow.)

The Beauprés marked the last day of 2009 in front of their home on Linden Avenue. It was built in 1941 for radio dealer George A. Withers and his wife, Flo Perkins Withers. Linda, holding Pablo the chihuahua, and Michael, are standing behind their seven-year-old twins Annabelle (left) and Grace, with Chloe the Catahoula-collie. (Photograph by Mike Beaupré, courtesy of the Beaupré family.)

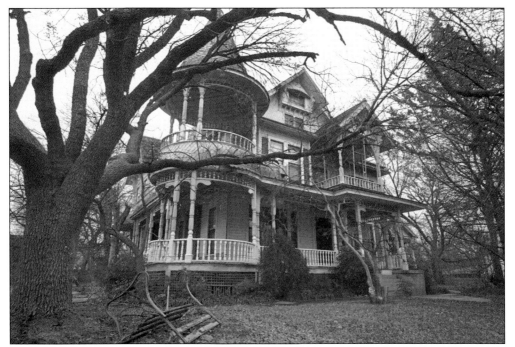

The McCart mansion changed hands in its ninth decade. Despite a passionate campaign to save it, the wrecking ball swung in 1971. The Texas State Historical Survey Committee approved a marker that was affixed, before several hundred witnesses, one day before demolition, Commitment to save another local landmark, Thistle Hill, grew after Arlington Heights' loss. (Courtesy of the *Fort Worth Star-Telegram* Collection, the University of Texas at Arlington.)

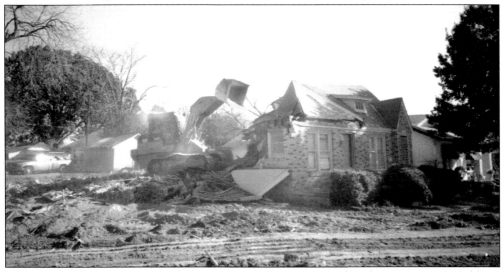

Teardowns began proliferating in the 1990s. This Hillcrest Avenue demolition prompted neighbors, located on one street over, to seek protective historic district status for their Tremont block; they named it Historic Hillcrest with the idea of encompassing more of the original addition. Authors of the 1988 historic resources survey noted that Hillcrest's streets south of Camp Bowie constituted "the best preserved 1920s neighborhood on the West Side." (Photograph by and courtesy of Christina Patoski.)

Muralist Stylle Read returned to Fort Worth in the winter of 2009 to touch up one of his works at Historic Camp Bowie Mercantile. Located on the Weatherford Traffic Circle, the antique mall wears scenes of Camp Bowie's colorful history on its exterior. Holt Hickman commissioned the paintings, and Read researched the history of the thoroughfare. (Photograph by Karl Thibodeaux.)

One of Read's Historic Camp Bowie murals is a montage featuring Steve's restaurant, a bomber from the Consolidated Vultee plant, and a tableau of Franklin Delano Roosevelt and Amon G. Carter dining together at the Original Mexican Eats Café. (Photograph by Karl Thibodeaux.)

SELECTED BIBLIOGRAPHY

Alter, Judy and James Ward Lee, eds. *Literary Fort Worth*. Fort Worth, TX: TCU Press, 2002.

Baugh, Timothy G., Stephen A. Hall, Christopher Lintz, and Tiffany Osburn. *Archaeological Testing at 41TR170, Along the Clear Fork of the Trinity River, Tarrant County, Texas*. Plano, TX: Geo-Marine, Inc., for Texas Department of Transportation, 2008.

Beautiful Arlington Heights: Residence Suburb of Fort Worth. Fort Worth, TX: Arlington Heights Realty Company, c. 1905.

Beyond the Blue: Lena Pope Home, 75 Years. Fort Worth, TX: Lena Pope Home, Inc., 2005.

Bristow, Nancy K. *Making Men Moral: Social Engineering during the Great War*. New York: New York University Press, 1996.

The Capsule: Base Hospital, Camp Bowie. Fort Worth, TX: U.S. Army, 1919.

Cashion, Ty. *The New Frontier: A Contemporary History of Fort Worth and Tarrant County*. San Antonio, TX: Historical Publishing Network, 2006.

The City of Fort Worth and the State of Texas. St. Louis and Fort Worth: G. W. Engelhardt and Company, 1890.

Cuellar, Carlos E. *Stories from the Barrio: A History of Mexican Fort Worth*. Fort Worth, TX: TCU Press, 2003.

Fort Worth, Near North Side and West Side—Westover Hills: Principal Findings and Resource Characteristics. Tarrant County Historic Resources Survey Series. Fort Worth, TX: Historic Preservation Council for Tarrant County, 1988.

Ginell, Cary, with special assistance from Roy Lee Brown. *Milton Brown and the Founding of Western Swing*. Urbana, IL: University of Illinois Press, 1994.

Hall, Flem. *Sports Champions of Fort Worth, Texas, 1868–1968*. Fort Worth, TX: John L. Lewis, 1968.

Kline, Susan Allen and the City of Fort Worth, Texas. *Fort Worth Parks*. Charleston, SC: Arcadia Publishing, 2010.

Krouse, Susan Applegate. *North American Indians in the Great War*. Lincoln, NE: University of Nebraska Press, 2007.

Lale, Cissy Stewart. *Sweetie Ladd's Historic Fort Worth*. College Station, TX: Texas A&M University Press, 1999.

Longworth, Philip. *The Unending Vigil: A History of the Commonwealth War Graves Commission, 1917–1967*. London: Constable and Company Ltd., 1967.

Makers of Fort Worth. Fort Worth, TX: Fort Worth Newspaper Artists' Association, 1914.

McGown, Quentin. *Fort Worth in Vintage Postcards*. Charleston, SC: Arcadia Publishing, 2003.

Roark, Carol, and Byrd Williams IV. *Legendary Landmarks of Fort Worth*. Fort Worth, TX: TCU Press, 1995.

Sanders, Bob Ray. *Calvin Littlejohn: Portrait of a Community in Black and White*. Fort Worth, TX: TCU Press, 2009.

Tyler, Ron, ed. *The New Handbook of Texas*. Austin, TX: Texas State Historical Association, 1996; and *Handbook of Texas Online*. www.tshaonline.org/handbook/online.

Williams, Joyce E. *Black Community Control: A Study of Transition in a Texas Ghetto*. New York, NY: Praeger Publishers, 1973.

DISCOVER THOUSANDS OF LOCAL HISTORY BOOKS
FEATURING MILLIONS OF VINTAGE IMAGES

Arcadia Publishing, the leading local history publisher in the United States, is committed to making history accessible and meaningful through publishing books that celebrate and preserve the heritage of America's people and places.

Find more books like this at
www.arcadiapublishing.com

Search for your hometown history, your old stomping grounds, and even your favorite sports team.